LEGENDAR

OF

BOZEMAN

MONTANA

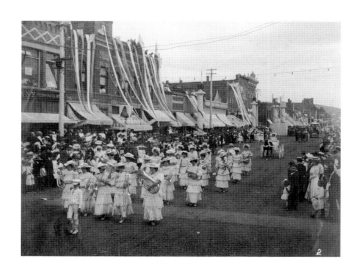

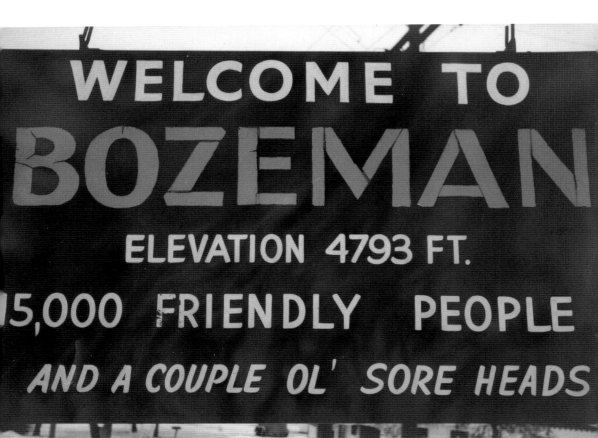

Bozeman Population Sign
Bozeman's Chamber of Commerce erected this unique "Welcome to Bozeman" population sign in 1957. (Courtesy of the Gallatin History Museum.)

Page 1: Ladies Imperial Band
Members of Bozeman's Ladies Imperial Band march down Main Street during the Sweet Pea Carnival on August 15, 1907. (Courtesy of the Gallatin History Museum.)

LEGENDARY LOCALS

OF

BOZEMAN

MONTANA

For John –
Thanks for everything, &
Enjoy!

Rachel Phillips

RACHEL PHILLIPS AND THE
GALLATIN HISTORY MUSEUM

LEGENDARY
LOCALS

Legendary Locals is an imprint of Arcadia Publishing
Charleston, South Carolina

Printed in the United States of America

Library of Congress Control Number: 2015948410

For all general information, please contact Arcadia Publishing:
Telephone 843-853-2070
Fax 843-853-0044
E-mail sales@arcadiapublishing.com
For customer service and orders:
Toll-Free 1-888-313-2665

Visit us on the Internet at www.arcadiapublishing.com

Dedication
To the people of Bozeman—past, present, and future.

On the Front Cover: Clockwise from top left:
Nelson Story Sr. (and family), rancher and businessman (courtesy of the Gallatin History Museum; see pages 16, 17); Godfrey Saunders, high school principal and educator (courtesy of Godfrey Saunders; see page 55); Eleanor Buzalsky, educator (courtesy of the Gallatin History Museum; see page 66); Ray and Kay Campeau, generous historic homeowners (photograph by Emily Marks; see page 122); "Golden Bobcats" basketball team, Montana State College (courtesy of the Gallatin History Museum; see page 81); the bicycle shop of William Ginn, business owner and cyclist (courtesy of the Gallatin History Museum; see page 82); Michael Langohr, florist (courtesy of the Gallatin History Museum; see pages 34, 35); Audrey Anderson, restaurant owner (courtesy of Steve Schlegel; see page 38); Fred Willson, architect (courtesy of the Gallatin History Museum; see page 96).

On the Back Cover: From left to right:
Heather McPhie, Olympic mogul skier (courtesy of Heather McPhie, see page 77); actor Gary Cooper and friends (courtesy of the Gallatin History Museum, see pages 102, 103).

CONTENTS

ACKNOWLEDGMENTS

Projects of this magnitude would not be possible without the knowledge, advice, and support of a great many people. My sincere gratitude and admiration goes out to my interviewees, information providers, and photograph suppliers—those featured on these pages and who helped behind the scenes. Pat Callis, Ginny Dieruf, Bill Lamberty, Faye Nelson and her crew at Warriors and Quiet Waters, Steve Schlegel, David Summerfield, and Dan and Katrin Voulkos provided me with crucial information, fascinating tidbits, and photographs.

Fellow colleagues and historians provided expertise, photograph research help, and encouragement; in particular Ann Butterfield, Jeff Malcomson at the Montana Historical Society, M. Mark Miller, Kim Allen Scott, and Charlie Spray. Any errors that may remain are my responsibility alone. Special thanks to my supportive editor at Arcadia Publishing, Erin Vosgien, who gave me valuable feedback. I am indebted to Gini Mohr, who generously donated her time to read my work and offer expert writing advice, as well as my fantastic photographer, Emily Marks, who made everyone feel as comfortable as humanly possible during photograph shoots. Thirteen of her photographs appear in this book.

In doing research, I relied heavily on the archives at the Gallatin History Museum, which provided invaluable information in the form of newspaper articles, obituaries, diaries, family histories, previously published local history texts, and 20,000 (and counting) fantastic photographs. Unless otherwise indicated, all images appear courtesy of the Gallatin History Museum. The museum's collection is truly a treasure trove. My deepest gratitude goes to the staff, board, and volunteers at the Gallatin History Museum, in particular Ken and Pat Hamlin, Bill Jones, and Cindy Shearer. Thank you all for the encouragement and generosity.

Finally, my family deserves much credit for the success and completion of this book, as they put up with long hours and urged me on every step of the way. But most of all, *Legendary Locals of Bozeman* would not exist without the incredible people—past and present—who make up our community. Many, many more people deserve to be included in these pages than space and time allow.

INTRODUCTION

Long before white settlers arrived, many people lived and hunted in what would later be called the Gallatin Valley, including Shoshone, Blackfeet, Crow, Salish, and many others. During the Lewis and Clark Expedition's return to the east in 1806, William Clark, accompanied by a small party that included Sacajawea, camped at Kelly Canyon (just a few miles east of present-day Bozeman). Fur trappers arrived in earnest in the first half of the 19th century and found success harvesting beaver pelts in the Gallatin Valley's abundant waterways.

In 1863, gold was discovered at Alder Gulch in a little creek that would one day become part of Montana Territory. Within months, thousands of miners flooded the area—among them an ambitious Georgian named John Bozeman. Bozeman soon abandoned the backbreaking work of a miner for the more romantic occupation of trailblazer. Along with John Jacobs, an experienced mountain man, Bozeman established a quicker route through present-day Wyoming to the booming gold-mining camps of Virginia City and Bannack. Splitting from the Oregon Trail in eastern Wyoming, the Bozeman Trail traveled northwest, passed east of the Bighorn Mountains, and crossed the Powder and Yellowstone Rivers before entering the Gallatin Valley from the east. Bozeman was optimistic that this new route—800 miles shorter than mountain man Jim Bridger's trail—would attract wagon trains anxious to reach the gold fields. However, while the development of this road was a shrewd business plan, the route itself was problematic as it trespassed through Sioux, Crow, and Cheyenne treaty-held territories.

Late in 1863, John Bozeman met visionaries Daniel Rouse and William Beall. The three agreed that the eastern end of the Gallatin Valley was a prime location for a settlement catering to tired and hungry immigrants. The new Bozeman Trail, descending from a mountain pass, travelled directly through this inviting area with abundant water and rich farmland. In the spring of 1864, Rouse and Beall constructed log cabins while they awaited John Bozeman's arrival from the east with a new group of immigrants. Their blueprint for establishing a new settlement worked according to plan. Farmers planted crops in the fertile soil at the foot of the Bridger Mountains, while merchants built general stores, mills, boardinghouses, and saloons.

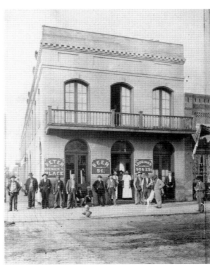

Metropolitan Hotel
The popular saloon at the Metropolitan Hotel, pictured here in about 1907, was located on the northeast corner of Main Street and Bozeman Avenue.

After John Bozeman's untimely death in 1867 (ostensibly at the hands of a party of Blackfeet), concerned citizens pushed the federal government to build a fort near town. Fort Ellis was in operation by the end of the summer of 1867, but its greatest value proved to be economic rather than protective. In addition to providing a stable and convenient market for local ranchers, the fort housed soldiers who often journeyed into town to spend their money.

It was not until 1883 that the Northern Pacific Railroad reached the now 20-year-old town. With the railroad providing easy shipping opportunities and sparking new confidence in future economic growth, construction boomed in Bozeman. New banks opened, impressive brick buildings replaced smaller frame structures, and traveling shows performed in a new opera house.

Bozeman continued to build and modernize in the early 1890s. After Montana attained statehood in 1889, Bozeman competed fiercely with Helena, Anaconda, and Butte for the honor of being the state capitol. City leaders transformed the town into a sophisticated city, building impressive structures and installing a modern electric streetcar line. Spacious Eighth Avenue boasted a boulevard intended to be a grand entranceway to the capitol building. Despite its efforts, Bozeman lost the capitol competition. However, it did gain an incredible asset in 1893: a land grant school named Montana State College of Agriculture and Mechanic Arts.

With the start of the 20th century, new ideas circulated among Bozeman citizenry. Hot issues like women's suffrage sparked local debate, and Bozeman ladies took the lead in campaigning for women's rights in Montana. The Women's Christian Temperance Union (or WCTU) grew along with local women's clubs fighting for a political voice.

As the population expanded and new ideas circulated, city promoters refocused on tourism. The Sweet Pea Carnival began in 1906 as a way to stimulate local commerce and quickly became a signature summer event. Excited locals adorned Main Street with streamers, coated carriages and automobiles in sweet pea blossoms, and crowned a Sweet Pea Queen. Sadly, however, global conflict found its way to the Gallatin Valley. After 1916, Sweet Pea Carnival celebrations ceased as the United States entered World War I. In 1918, without even a reprieve after the war's end, the infamous Spanish Influenza epidemic hit Bozeman. Nonessential activities ceased, opera house entertainment was suspended, and schools closed as their buildings were repurposed as sick wards.

Eventually, the epidemic eased and life returned to normal. Reinvigorated, investors set to work building a massive fairground on Bozeman's northeast side. The completed grandstand and stadium seating accommodated over 15,000 excited fans for races and rodeos. From 1919 to 1926, the Bozeman Roundup was a popular event on the Western rodeo circuit, attracting nationally-known cowboys and cowgirls. In the late 1910s, a new industry joined flour mills as a major employer. The Bozeman Canning Company was established in 1917 after studies showed that seed peas grew well in the Gallatin Valley. Until its closure in 1961, the pea-canning company employed hundreds of locals both in the fields and in the plant. The dependable work, though rationed, proved beneficial to Bozeman families during the lean years of the Great Depression.

From the beginning, Bozeman's nearby mountain ranges and rivers provided fantastic hunting and fishing, but in the mid-20th century, skiing increased in popularity. Downhill skiing enthusiasts enjoyed runs in nearby Bear Canyon, and in 1954 the Bridger Bowl ski area opened. As the winter sports industry expanded in the 1950s and 1960s, noticeable population growth stimulated construction of new buildings and subdivisions, a trend that continues today. In 1965, Montana State College became Montana State University, and its student population topped the 5,000 mark (the school's current enrollment exceeds 15,000). A renewed emphasis on culture led to a revival of the old Sweet Pea Carnival in 1978 under a new name, the Sweet Pea Festival of the Arts.

Now one of Montana's fastest growing cities, Bozeman still retains elements of the past while looking to the future. Streets named Alderson, Rouse, and Willson pay homage to early founders, while new start-up companies coexist with 100-year-old businesses. Educators and pioneering thinkers stimulate new ways of thinking, and artists, musicians, and entertainers add to the local culture. Sports legends and outdoor athletes continue to amaze, and inspiration emanates from extraordinary individuals. All contribute to Bozeman's future as a priceless mountain gem.

CHAPTER ONE

Founders, Early Residents, and Firebrands

Bozeman City began as a stop on the Bozeman Trail in 1864. Scores of immigrant wagon trains lumbered their way out of Bozeman Pass and down into the fertile Gallatin Valley. Most continued on to Virginia City and Bannack, hoping to strike it rich. A few stayed, and the town grew as cabins, hotels, and small wood-frame homes rose out of the beaver dam–filled swamps at the eastern end of the valley. In July 1864, William Alderson described his first glimpse of the Gallatin Valley: "Here the place (valley and stream) looked so pleas[ant] and inviting that we concluded to lay over and look around . . . Weather delightful." Alderson was not alone in his sentiments. Many adventurous spirits planning only a short layover before continuing westward abruptly changed their minds after realizing there were easier paths to wealth than mining for gold.

The new settlement soon formed the Bozeman Claim Association, an early governing body that included visionaries, farmers, and businessmen like John Bozeman, William Alderson, and Daniel Rouse. Recognizing the agricultural and economic potential of the fledgling town, entrepreneurs established enterprises that proved highly profitable. Lumberman George Flanders capitalized on the influx of new immigrants to the area by supplying building materials. George and Elmira Frazier ran a boardinghouse that provided lodging for scores of single men. Haitian-born barber Samuel Lewis found tremendous success keeping the men of Bozeman well groomed. The rich lands surrounding the new town brought opportunities as well. Though he met with success mining near Virginia City, early entrepreneur Nelson Story switched to cattle ranching, soon becoming one of Montana's first millionaires.

After establishing homes and farms in the new community, single men journeyed east to find wives. New female residents quickly became novelties in the male-dominated surroundings. Young bride Sarah Tracy noted in her diary the curious fascination paid her by Bozeman men upon her arrival in 1869. Gradually, this domestic female presence began to transform the collection of log cabins into a community. One of these influential women, Mary Hunter Doane, sparked an interest in historic preservation through her early work with the Pioneer Society in Gallatin County.

Like most cities, Bozeman had its share of dramatic events and criminal activity. John Bozeman's untimely death in 1867 sparked a debate that continues to this day. Several executions by hanging (some legal and some not) occurred in the area from time to time, with the details passing into local legend. The Big Horn Gun, a familiar sight in Bozeman since it was abandoned in 1870, uttered one last boom on the night of March 20, 1957, when unidentified mischief-makers awoke it from a peaceful slumber in front of the courthouse on Main Street.

Some men and women landed in Bozeman by accident, while others came with a vision of a prosperous future in the Gallatin Valley. The unique character of these early residents contributed to the endurance and continuing success of the community. As it quickly transformed into a city with an air of anticipation for the future, Bozeman became more than just a stop on the road to the mining camps.

John Bozeman

Georgia native John Bozeman arrived in the future Montana Territory in 1862. He was lured west by the promise of gold, leaving behind his wife and three young daughters. Following his arrival in Montana, Bozeman realized fairly soon that he was not cut out to be a miner. The tall, strong, well-dressed, and handsome southerner discovered trailblazing was more to his liking. In 1863, Bozeman and a partner, John Jacobs, began work to establish a new route to the Montana gold fields, one that would eliminate weeks of travel time and hundreds of miles. The Bozeman Trail branched off the Oregon Trail in eastern Wyoming and pushed northward through treaty-held Sioux, Crow, and Cheyenne lands. Despite the problems with the trail's route, the shorter travel time attracted immigrants, and Bozeman met with success.

In 1864, the Bozeman Claim Association, an early governing body, was established at the little settlement along the Bozeman Trail on the eastern edge of the Gallatin Valley. Secretary William Alderson suggested the new town be called Bozeman in honor of John Bozeman's contributions to the settlement of the area. The motion passed, and Bozeman himself was elected recorder of all land claims for the association. Later that year, the association entertained a motion to change the name of the town to "Montana City"—a hint that Bozeman's celebrity status was beginning to wane. Perhaps his good looks, gambling habits, Southern origins, and business schemes were rubbing some people the wrong way.

In mid-April 1867, Bozeman and fellow businessman Thomas Cover left town and struck an eastward course, hoping to market Gallatin Valley agricultural products to US Army posts along the now virtually abandoned Bozeman Trail. On the second night of the journey, Bozeman and Cover camped along the Yellowstone River east of present-day Livingston. According to Cover, who stumbled into Nelson Story's cow camp later that night bedraggled and alone, the two men were cooking over their campfire when a party of five Blackfeet Indians approached. Bozeman, at first thinking one of the men was a Crow acquaintance, prepared food for the guests. In Cover's version of events, Bozeman quickly realized his mistake, and a gunfight ensued. Bozeman was shot twice in the chest, perishing at the campsite. Through the years, stories changed and new accounts came to light, making it difficult to determine what actually occurred that night. Doubts endure, and debate over the identity of the real culprit(s) continues to this day.

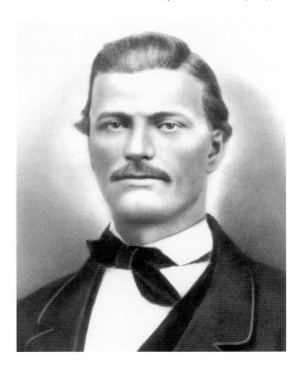

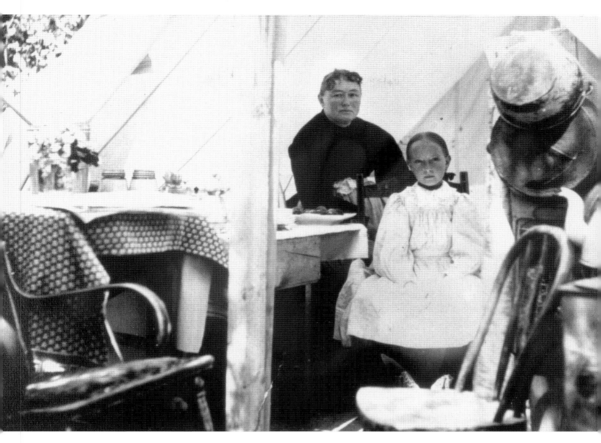

Sarah Tracy

In 1869, Bozeman was beginning to resemble a community. Businesses sprang up, and men journeyed east, each eager to return with a wife. One such spouse was Sarah Tracy, bride of local businessman William H. Tracy. Upon her arrival in Bozeman, she was greeted at the hotel by a crowd of men and only two other women. Seventeen-year-old Sarah never forgot her first meal in town. She wrote in her diary, "When supper was served a little later . . . every stool around the two long tables was occupied—Mrs. [Sophia] Guy, Mrs. [Ellen] Story and I being the only ladies. It did look somewhat like curiosity . . . I wonder if they thought Mr. Tracy's investment was a good one." Hotel proprietor John C. Guy admitted to Sarah Tracy afterward that such a large guest list (more than 70 men) was irregular. Sarah, who also went on to write a fascinating reminiscence about her trip to Yellowstone in 1873, is pictured here with her daughter, Edna Tracy White.

Samuel Lewis

Haitian native Samuel Lewis landed in Bozeman in 1868. Born in 1832, Lewis immigrated to the United States with his parents early in life. After only a few years in New Jersey, both of Lewis's parents passed away, leaving him responsible for his younger siblings. Eventually, he followed his adventurous spirit and experienced the wonders of Europe before heading toward the mining camps of the American West. Rather than working himself to exhaustion cutting into the earth like most miners, Lewis ventured into cutting something else—hair. Instead of a pickax, his tool of choice became scissors. Perhaps not all barbers were as successful as Lewis, but the career paid off for him.

By the time he arrived in Bozeman, Lewis's significant assets allowed him to purchase a large lot on Main Street. The Lewis Block provided space for several businesses, including Lewis's own enterprises. Only a handful of African American families lived in Bozeman prior to 1900, and even an out-of-the-way northern frontier town like Bozeman had its racial problems, but Lewis quickly gained popularity. He was deeply involved in city issues, a prominent businessman, and a spectacular musician. People enjoyed his informal concerts, during which he sang and played a variety of instruments, including a harp.

Samuel was not the only talented sibling in the Lewis family. His younger sister Edmonia showed incredible artistic promise, and with Samuel's encouragement, she was accepted at Oberlin College at age 16—an impressive accomplishment for a young African American woman on the eve of the Civil War. After Edmonia graduated, Samuel, always the supportive older brother, paid her way to Europe, where she studied art in Italy. Edmonia Lewis became a famous sculptor, and her work is on display in museums around the United States. Samuel died in Bozeman in 1896. According to his obituary in the *Avant Courier* newspaper, his estate provided $25,000 for his wife and children, much of the town attended his funeral, and the mayor served as one of his pallbearers. Not bad for a barber.

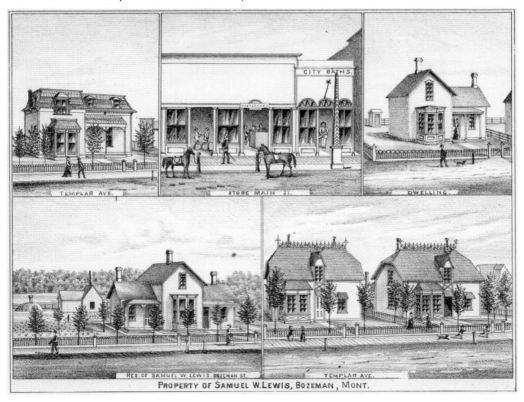

PROPERTY OF SAMUEL W. LEWIS, BOZEMAN, MONT.

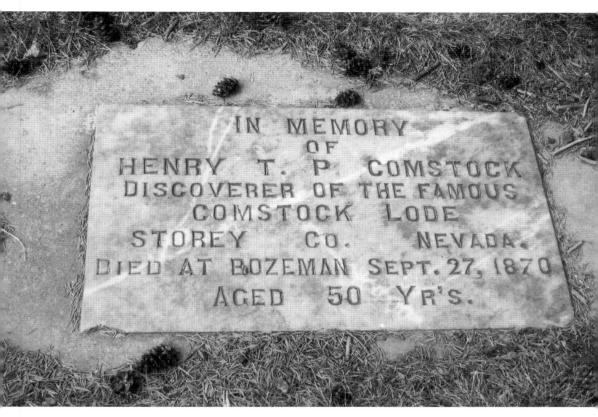

Henry Comstock

September 27, 1870, marked the suicide of one of Bozeman's most nationally renowned (if not one of its briefest-residing) citizens. Nevada silver miner Henry Comstock, or "Old Pancake," managed to cement his name in American history before his life ended tragically in Bozeman. After selling his share of the Comstock Lode in Virginia City, Nevada, the ambitious miner traveled north hoping to strike it rich but never meeting with success. He joined a group of prospectors in Wyoming; they finally ended their unsuccessful search after arriving in Bozeman, where the group's members parted ways. Comstock, who by that time was broke, homeless, and disliked by virtually everyone, lived out the rest of his days alone in a hovel on Main Street before ending his own life. (Courtesy of the author.)

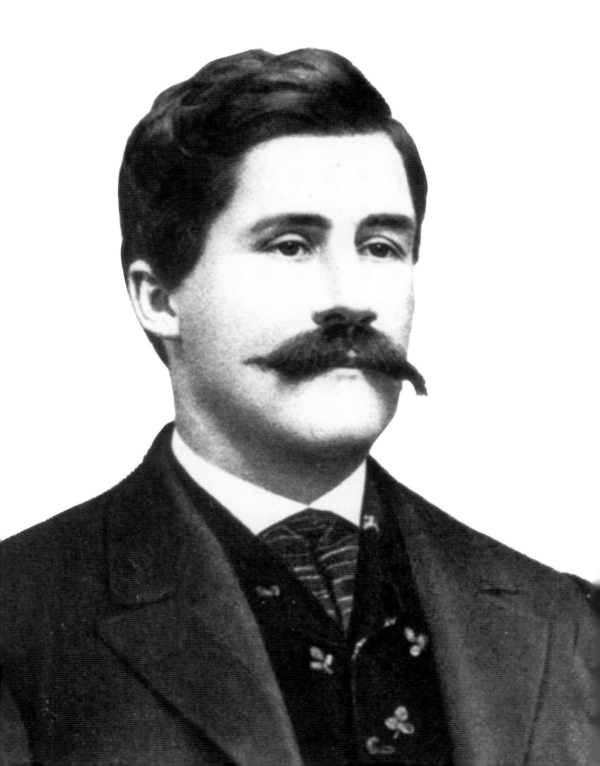

Thomas Cover (OPPOSITE)
A member of the Fairweather party that struck gold in Alder Gulch, Montana in 1863, Thomas Cover was an enterprising individual and a successful businessman involved in one of the earliest flour and grist mills in Montana Territory. In 1867, he made statewide news after surviving the mysterious incident along the Yellowstone River that killed his traveling companion, John Bozeman. Cover's incredible story of that night sparked a debate that continues to this day, but the truth will likely remain a mystery. Two years after Bozeman's death, Thomas and his wife Mary relocated to Riverside, California. In 1884, Cover joined a prospecting party in Southern California's Colorado Desert. During the journey, the group split up, intending to cover more ground before rejoining. Cover never arrived at the scheduled meeting place, instead disappearing without a trace. (Courtesy of Montana Historical Society Research Center—Photograph Archives, Helena, MT.)

Lester Willson
Born in Canton, New York, in 1839, Lester Willson (shown here standing behind his family) enlisted in the Union Army in 1861. By the end of the Civil War, he held the title of brevet brigadier general. After participating in several major battles, including those at Antietam and Chancellorsville, Willson finished the war under General Sherman during his march through the South. Soon after the war's end, Willson left the east for Montana, where he and two associates, Charles Rich and L.W. Fuller, opened a general store in Bozeman. Upon his arrival in town in late April 1867, Willson later recalled only about 12 log cabins, a Masonic hall, and a flour mill. After a few years, Willson bought out his partners and ran a successful downtown business, The Willson Company, for the rest of his life. After his death in 1919, Central Avenue in Bozeman was renamed Willson Avenue in his honor.

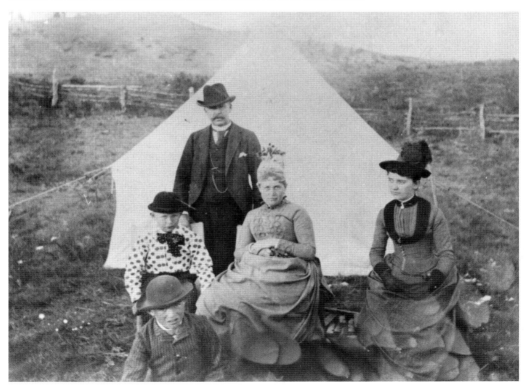

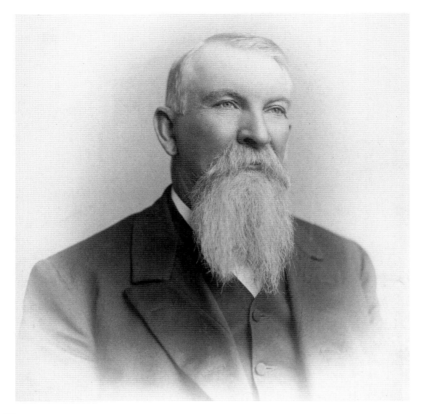

Nelson Story

According to his grandson Malcolm, Nelson Story "always wore a flat top Stetson, a long tailed coat and walking boots" and "was on hand when Bozeman was established as a town on August 8, 1864." Born in 1838 in Ohio, Story struck out on his own at age 19, starting in Leavenworth, Kansas. In the ramshackle mining towns of the western United States, food and basic supplies were often difficult to acquire. Story quickly saw his opportunity and established a freighting business that shipped goods from Leavenworth to tiny Denver, Colorado. After a brief stint in silver mining, Nelson Story packed up and headed north to Montana in 1863, where he staked out gold mining claims near Alder Gulch that eventually netted him $30,000.

Despite the gold fever spreading around him, Story made his freighting career a priority. He partnered with several other men to establish the Yellowstone Transportation Company, which utilized the Yellowstone River to ship goods into Montana Territory. He quickly realized the potential economic advantages of raising beef to supply the area's booming mining towns, and by the late 1860s, Story was running a profitable cattle ranch in the Upper Yellowstone Valley near present-day Livingston, Montana. Thanks to the highly successful ranching operation, Nelson and his wife, Ellen Trent Story, settled in Bozeman, where the patriarch invested his time and money in banking, real estate, and even a flour mill. As one of Montana's first millionaires, Story generously gifted land on Bozeman's south side to the fledgling Montana State College of Agriculture and Mechanic Arts. His impressive three-story mansion on Main Street had running water made possible by piping spring water to an attic tank, which used gravity to do the rest. The spring water came from what would later become the Montana State College "Frog Pond" (now known as the "Duck Pond"). Nelson Story (pictured at right with his sons) died in 1926, and his grand home was dismantled in 1938 to make room for the Willson School gymnasium. The spectacular columns that once graced the front door of his mansion now stand guard at the Story family plot in Bozeman's Sunset Hills Cemetery.

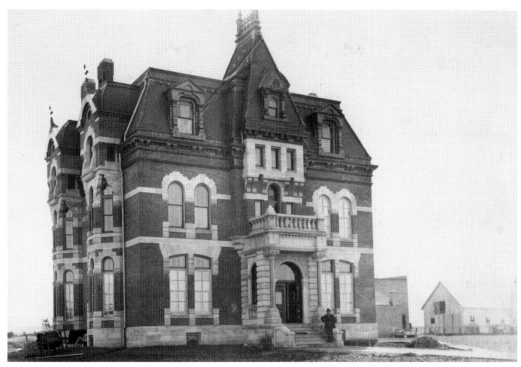

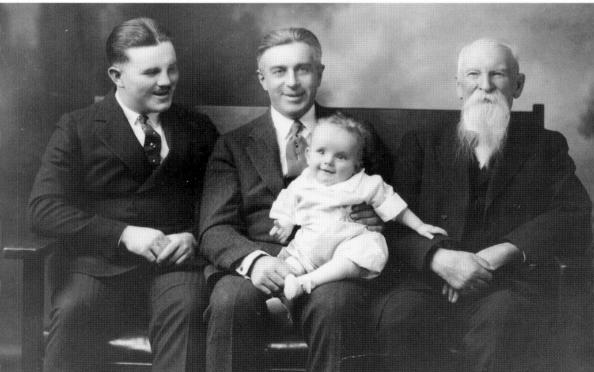

Flora Gardner

In 1879, Flora Gardner journeyed from Kansas to Bozeman with her family; like many immigrant parties of the day, they traveled via steamboat and wagon. In a letter to friends, Gardner described the trip's adventures in fascinating detail. Providing a glimpse into the immigrant experience, Flora remembered the overland trek: "If the wagon touched the ground for nine miles, we did not know it. The boys made several speeches that did not sound like their prayers."

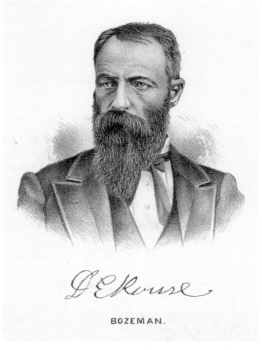

BOZEMAN.

Daniel Rouse

An enthusiastic settlement developer from Michigan, Daniel Rouse indulged his love of platting streets at Gallatin City before teaming with John Bozeman and William Beall to establish the city of Bozeman. Rouse was instrumental in the initial planning of the site in 1864, and he made Bozeman his permanent home until his death in 1912. In the 1980s, a headstone was finally placed on his unmarked grave in Sunset Hills Cemetery.

Rosa Beall

Early Bozeman resident Rosa Beall passed away at age 91 in 1930. Over her 65 years in town, she witnessed Bozeman's transformation from a handful of log cabins to a sophisticated city boasting electricity and paved streets. She arrived with her first husband and two small daughters in 1864. Difficult times ensued, and her husband took the children and left, abandoning Rosa. She never saw her daughters again, and, sadly, neither survived to adulthood. Rosa married William J. Beall in 1868, and they made their home on the north side of town. Nearly 20 years after William's death in 1903, Rosa downsized and moved into the Evergreen Apartment building, staying active in St. James Episcopal Church for the rest of her life. A portion of William and Rosa's property on North Bozeman Avenue is now Beall Park (pictured above is the Beall Park Recreation Center building). (Above, photograph by Emily Marks.)

Seth Danner

On July 18, 1924, Seth Orin Danner was executed by hanging in the Gallatin County Jail after being convicted of the 1920 murders of John and Florence Sprouse. Seth's wife, Eva, exposed the crime to a sheriff's deputy in 1923, perhaps spurred on by the couple's deteriorating relationship. As Eva explained, the two couples were camping together along the Gallatin River that summer, trapping and hunting. One evening, the two men left the campsite to tend to their traps, and only Seth returned. Eva claimed that Seth killed John, then murdered Florence Sprouse with a hatchet after she repeatedly questioned him about John's whereabouts. Throughout his trial, Seth admitted to bootlegging and the occasional robbery, but he was emphatic that he was no murderer. Seth Danner suggested that Florence Sprouse's violent ex-husband was to blame, but was convicted nonetheless.

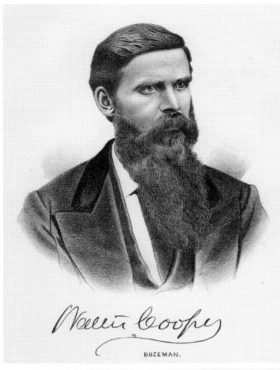

BOZEMAN.

Walter Cooper

In 1872, fur trader, gunsmith, and entrepreneur Walter Cooper constructed one of Bozeman's first brick buildings on Main Street (shown at right in the photograph below) between what are now Black and Bozeman Avenues. In addition to his work with firearms, Walter Cooper served as one of Bozeman's first aldermen and lent his talents to the governing board of Montana State College of Agriculture and Mechanic Arts, the brand-new agricultural college granted to Bozeman in 1893. He also dabbled in a variety of local business enterprises, including a bank and lumber operations in both nearby Bear and Gallatin Canyons. His Gallatin Canyon property boasted several logging camps that created railroad ties to sell to the Northern Pacific Railroad. A portion of his impressive brick building is still in use today at 118 East Main Street.

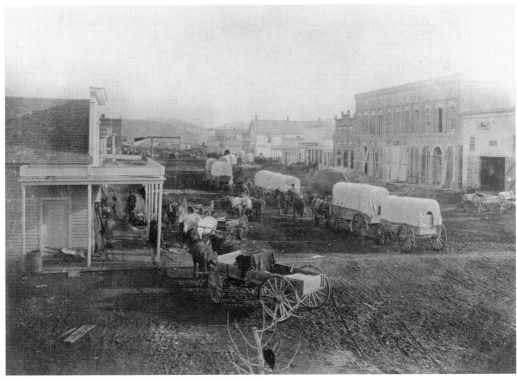

William and Mary Blackmore

Wealthy English couple William and Mary Blackmore stopped in Bozeman in 1872, intending to take a brief rest before exploring Yellowstone. However, Mary became suddenly ill, and Lester and Emma Weeks Willson welcomed the couple into their home. Sadly, Mary died only days after her arrival. William Blackmore purchased several acres of land on a hill overlooking town, buried his wife, and donated the land to the city. One can still find Mary's pyramid-shaped gravestone in what is now Sunset Hill Cemetery. Her marker mimics the form of Mount Blackmore in the Gallatin Range, named in her honor by Dr. Ferdinand Hayden, Yellowstone explorer and recipient of financial backing from William Blackmore. As for William, he returned to England, where his empire crumbled and his life tragically ended in suicide.

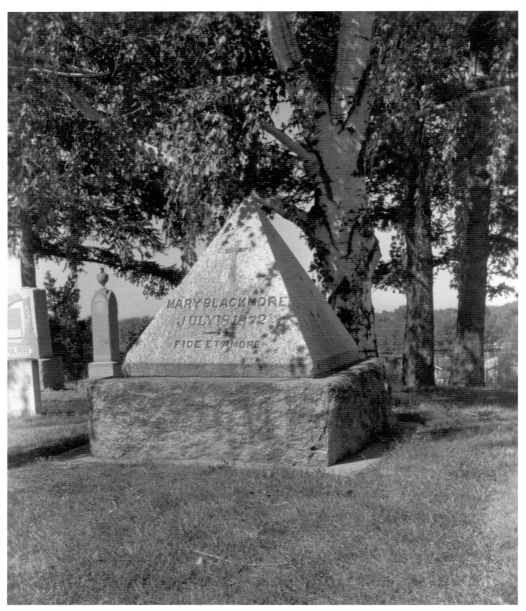

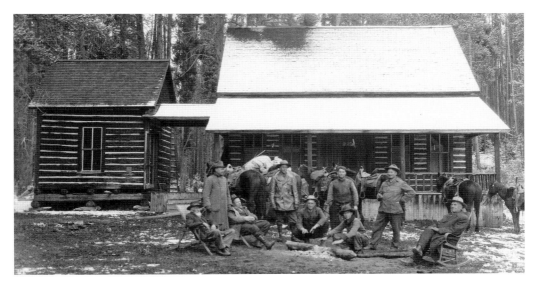

George Flanders

As a young man in Vermont, George Flanders gained considerable experience in the lumber mill trade. Once in Montana, Flanders worked as a millwright in Helena, eventually moving to Bozeman and starting his own mill in Bear Canyon. Though Bozeman was a young settlement, new settlers were always in need of lumber and shingles, so Flanders expanded his operation to Middle Creek Canyon, south of Bozeman, in 1877 (the Flanders Mill Pond at Middle Creek Canyon is seen below in 1952). He is pictured above (likely on the left) with a group of friends in Middle Creek Canyon (now Hyalite Canyon). After the Northern Pacific Railroad reached Bozeman in 1883, Flanders was able to establish a lumber yard in town to cater to new residents. Eventually, his logging operation at Middle Creek waned as profitable timber became scarce. After retiring from the lumber industry, Flanders continued to operate a small farm at his former mill site on Middle Creek.

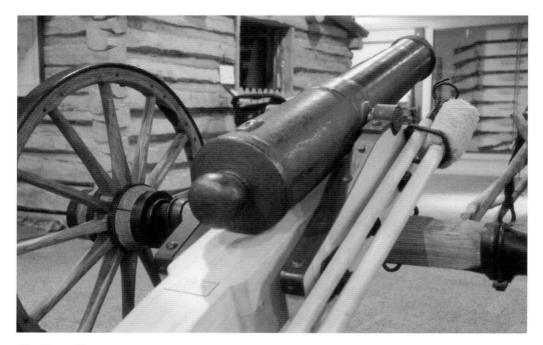

Big Horn Gun

Much of the history of the Big Horn Gun is unknown; but, nonetheless, the cannon played an important part in Bozeman's military and social history. Likely cast in Europe in the later part of the 18th century, the weapon's arrival in Bozeman dates to 1870, when Henry Comstock and his group of down-on-their-luck Wyoming gold miners halted their wanderings in Bozeman, leaving the gun with local mill owner Perry McAdow.

Four years later, after restoration by local gunsmith Walter Cooper, the Big Horn Gun accompanied the Yellowstone Wagon Road and Prospecting Expedition on a journey into eastern Montana. During preparations for the trip, it was discovered that oyster cans from Lester Willson's store fit the gun's barrel perfectly. Expedition members were all too glad to assist in removing the original contents of cases of donated oyster cans, after which the containers were filled with shrapnel. In his reminiscences, guide Jack Bean remembers the gun's distinctive sound during firing—"where is yee, where is yee, where is yee"—as the contents of the tin cans went in every direction.

After the 1874 expedition, the Big Horn Gun led a somewhat quieter existence, only being fired off on special occasions, such as the arrival of the Northern Pacific Railroad in 1883. The icon eventually came to rest in front of the Gallatin County Courthouse on West Main Street, where locals used it for photograph opportunities. The gun's most recent firing occurred in the middle of the night on March 20, 1957, when an unknown group loaded it up and lit a fuse, waking the sheriff and breaking windows in the courthouse and Gallatin County High School across the street. The culprits never came forward, but as a preventative measure against future disruption, the cannon's barrel was filled with concrete. The Big Horn Gun was removed from the courthouse lawn in 1994, restored, and given a new wheeled carriage before being put to rest in the Pioneer Museum (now the Gallatin History Museum), where visitors can safely enjoy it. (Photograph by Emily Marks.)

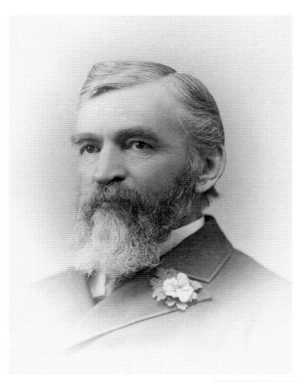

William Alderson

In 1864, Englishman William Alderson described the Bozeman area as "inviting" while spending his first summer constructing cabins and farming. A cheerful fellow, he wrote in one of his diary entries, "Made about 2# butter; then had a sing in the shower." Alderson worked his land claim and served as secretary for the area's first governing body, the Bozeman Claim Association. The talented Alderson was also a reverend, participated in territorial and state government, and owned Bozeman's *Avant Courier* newspaper.

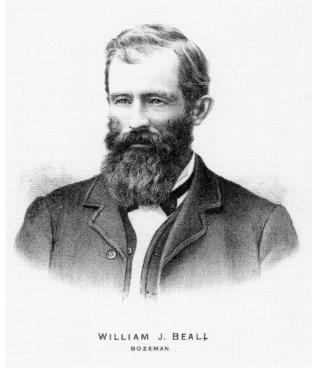

WILLIAM J. BEALL
BOZEMAN.

William Beall

A carpenter from Pennsylvania, William Beall turned to farming in the Gallatin Valley, where, in 1864, he began constructing the future town of Bozeman along with Daniel Rouse. Beall was not only a carpenter but also a builder, architect, and planner who initiated the layout of Bozeman's grid-like streets and constructed the first frame structure in town. He remained a respected Bozeman citizen until his death at age 69 in 1903.

Gustavus Doane

Gustavus Doane traveled west along the Oregon Trail with his parents in 1846, and the family eventually settled in California. After graduating from the University of the Pacific in Santa Clara, he served in two different regiments in the Civil War. Doane married his first wife, Amelia, in 1866, and after he reenlisted in the Army the couple found themselves transferred to Fort Ellis in Montana Territory. His first marriage fell apart, and he married Mary Hunter (pictured below), a local doctor's daughter, in 1878. A well-educated writer, Doane was excited to join the 1870 Yellowstone Expedition as a military escort. His report of the journey was a valuable early account of the wonders in what would later become Yellowstone National Park, but he never received the fame and recognition he desired. Doane died of heart failure in Bozeman in 1892.

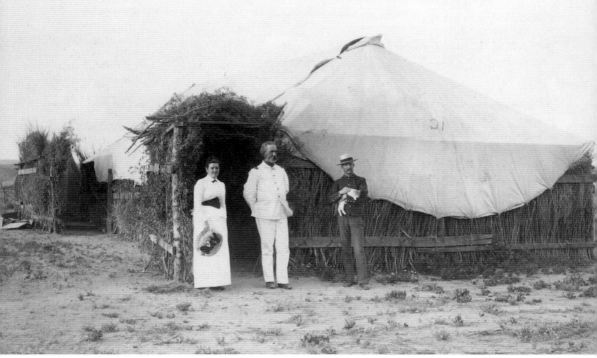

Mary Hunter Doane

Illinois native Mary Hunter arrived in Montana
Territory in 1864 with her family. Mary's father,
Dr. Andrew Jackson Hunter, established a resort
east of present-day Livingston at Hunter's
Hot Springs. Dr. Hunter's bathhouses proved
successful, and in 1885 he sold the business
and settled in Bozeman. Mary attended private
schools in the Gallatin Valley and Helena,
Montana, before meeting Lt. Gustavus Doane.
Despite their age difference (Lt. Doane was 20
years older), the two married in 1878. During
their marriage, the couple moved frequently
following Doane's military assignments, but after
her husband's death in 1892, Mary remained in
Bozeman. She was interested in local history
and was involved in DAR and the Pioneers'
Society in Gallatin County. Mary assisted the
DAR in placing historical markers around the
Bozeman area, and her photographs of old Fort
Ellis remain invaluable resources. She is pictured
below (third from left) with some poker-
playing friends.

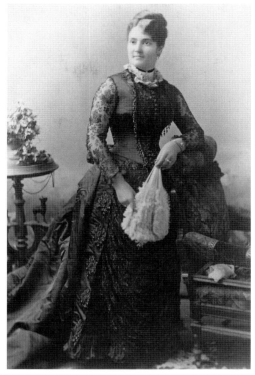

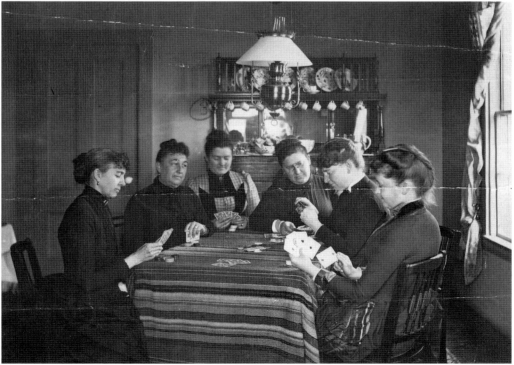

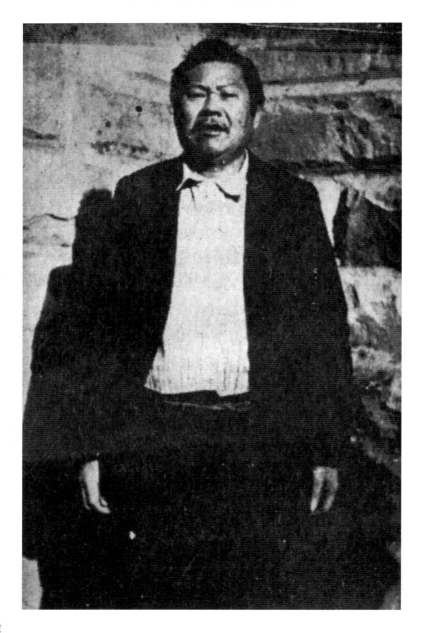

Lu Sing

Lu Sing's history represents some of the darker aspects of Bozeman's early years. On October 3, 1905, a Chinese immigrant named Tom Sing was killed with a hatchet in a local restaurant. Lu Sing (unrelated to the victim) was arrested for the crime, but his motive was fuzzy. Theories ranged from a murder-for-hire plot to a crime of passion involving Tom Sing's wife. Lu Sing's defense attorney argued that other members of the Chinese community forced him to commit the act on pain of death. All arguments failed, and the prisoner was sentenced to hang. Lu Sing was executed in the wee hours of the morning on April 20, 1906. Disturbingly, the execution did not progress as smoothly as it should have, and it was not until 15 minutes after the platform dropped that Lu Sing was pronounced dead. As the newspapers described, this was more of a "strangulation" than a "clean hanging."

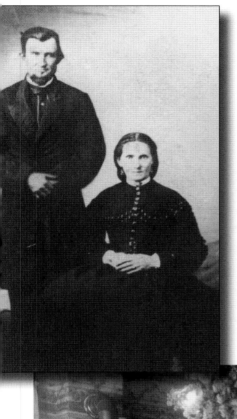

George and Elmira Frazier

In 1866, Georgia natives George and Elmira Frazier opened a new hotel in Bozeman complete with a swinging business sign. Like most hotels of the day, the City Hotel depended on long-term lodgers like John Bozeman, who frequently occupied a room upstairs. On the morning of April 17, 1867, the Fraziers bid farewell to John Bozeman as he left with Thomas Cover on an eastward journey along the Bozeman Trail. According to historian Phyllis Smith, after giving Bozeman a packed lunch, Elmira remarked to her husband, "Isn't Bozeman a handsome man?" to which her husband George replied, "Take a good look, you're never going to see him again." If accurate, this exchange could suggest some interesting possibilities regarding Bozeman's death. In 1871, George and Elmira built a new hotel, the Frazier House, on East Main Street. The decorated interior of the Frazier House is shown below.

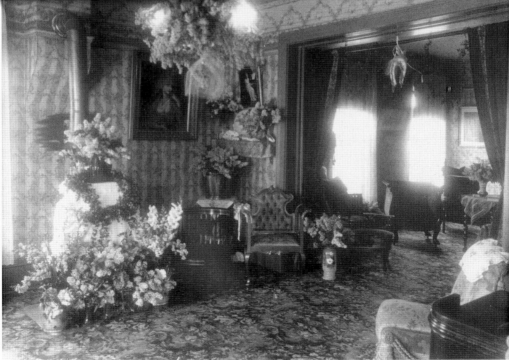

Jack Bean

Seeking adventure in the gold fields of Colorado with his brother-in-law, Jack Bean (seen here on the left) left home at age 16 with his mother's permission and her request that he return home in two months. Twenty-nine years later, he finally reunited with his mother. Bean mined, hunted, and trapped before finding his niche as a wilderness guide. His fascinating diary records adventures with the military, Yellowstone explorers, and wealthy Englishmen. One rather amusing episode occurred while guiding a Colonel Pickett through Yellowstone Park. Anxious to kill a bear but not particularly observant, Pickett kept missing Bean's sightings, straightening up with the question, "Whar?" Bean writes, "I advised him that a bear didn't wait for a man to tie his shoe." Bean homesteaded near Bozeman, married, and eventually retired in California. Besides his written diary, some of his hunting adventures were preserved in pictures taken by his brother-in-law, photographer Charles D. Loughrey.

CHAPTER TWO

Business and Community Leaders

It takes a group of dedicated individuals to lead a community, including politicians who have the courage to stand up for what they believe in and entrepreneurs that, through hard work and dedication, create lasting businesses. Bozeman's first governing body, the Bozeman Claim Association, first met on August 9, 1864, to establish early laws and provide guidelines on land claims. When the city incorporated in March 1883, Mayor John V. Bogert set to work organizing city government and leading eight alderman in implementing Bozeman's first city ordinances. New laws outlawed public drunkenness and cursing, set standards for keeping the city clean, and introduced new sign regulations.

Other political leaders emerged to make their marks on Bozeman, Gallatin County, and Montana history. In 1936, Mabel Cruickshank became the first woman from Gallatin County elected to the state legislature. Known for her pioneering work on the Montana State Constitutional Convention of 1972, state senator Dorothy Eck worked to provide much-needed additional resources for mentally-ill patients in Bozeman and Gallatin County.

Early business owners shaped the local economy and paved the way for the success of future endeavors. Some entrepreneurs created lasting businesses that served the Bozeman community for decades. What began as a gardening hobby for Michael Langohr on his days off soon transformed into a massive greenhouse operation thanks to his green thumb. Henry Jacobs advertised his cleaning service with a hilarious delivery vehicle: a human-sized barrel that invited customers to "hop in" while their clothes were washed. Restaurant owners Chin-Au-Ban, Audrey Anderson, and Manny Voulkos found their ways into the hearts and memories (if not the stomachs) of loyal patrons. Minnie Mercer Preston owned the Chambers-Fisher Department Store on Main Street for decades and was an early advocate for supporting locally-owned downtown businesses. Following a passion for books, Mary Jane DiSanti purchased a local bookstore and, over 30 years, cemented the business into a Bozeman mainstay.

Some community leaders left an unforgettable legacy. Anyone living in Bozeman from the 1950s to the early 1980s would likely recall Judge William Wallace Lessley, particularly if one found oneself in the courtroom on the other side of the law. Besides serving as a district court judge, Lessley taught law, presided over a variety of local organizations and clubs, and instituted a nationally recognized Citizenship Day program in 1949.

New civic and political leaders are continually emerging, while small businesses and start-up companies cater to Bozeman's locally-minded citizenship. Initiative, dedication, and unique ideas jump-started the community 150 years ago and will continue in years to come.

Dorothy Eck

Dorothy Eck laughingly related to interviewer George Cole in 2012 that she used to have a sign on her desk with the word "Plan" crossed out and replaced by the word "Scheme." One of Montana's pioneering female politicians, Eck is well known for her work on the state Constitutional Convention in 1972, her 20 years as a Montana state senator from Bozeman, and her tireless work to create support structures for families in crisis and the mentally ill.

Born in 1924 in Sequim, Washington, Eck grew up with a supportive family. After graduating high school, she made plans to attend college in Tacoma, but World War II put everything on hold. Instead, she met her future husband, Hugo, who was working as a naval architect in Tacoma. After the war, the Ecks moved permanently to Bozeman, where Hugo began teaching architecture at his alma mater, Montana State College. The couple built their own home, and Dorothy went on to obtain degrees in sociology and, later, an honorary PhD from Montana State University.

Dorothy's interest in politics began during her high school years in Washington. She remembers following political campaigns, taking notes on frontrunners and calculating candidates' chances of nomination. Her excitement for politics led to involvement, and in the early 1970s, she was elected as a delegate to the 58-day-long Montana Constitutional Convention, where she served on the bill of rights committee. Besides serving three terms as president of the League of Women Voters, Dorothy also spent 20 years as a Montana state senator in the 1980s and 1990s. Through her long political career, she worked to increase support for children and families, fought to protect the environment from the harmful effects of coal mining, and expanded resources for mentally ill patients in Bozeman. Appreciative of her work in support of mental health, the Gallatin Mental Health Center named an apartment building on their campus the Dorothy Eck House in 2010. Through this honor and countless others, Dorothy's political and social legacy will endure for many years to come. As she concluded to George Cole in 2012, "I have always said politics is really a disease and once you get into it . . . you can understand you'll have a possibility of making a difference. I think that is where I'll be." (Photograph by Emily Marks.)

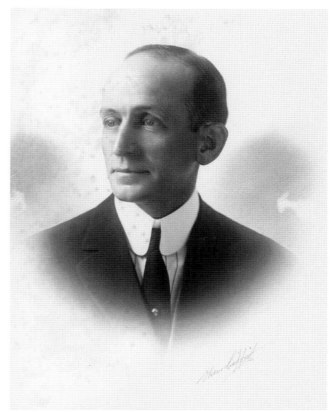

Sherman G. Phillips

Sherman G. Phillips's 1939 obituary states that he "was a voracious reader." It is fitting, then, that he owned and operated Bozeman's most enduring book and office supply store to date, which finally closed its doors on July 9, 2012. Phillips came to Bozeman in 1883 and got a job at the Willson Company Store. In the early 1890s, he purchased an existing bookstore, named it Phillips Book and Office Supply, and marketed stationery and office supplies in addition to fiction and nonfiction books. A true bookworm, he amazed customers with his ability to remember and discuss most of the published material sold in his shop. The store interior is seen here with an unidentified employee.

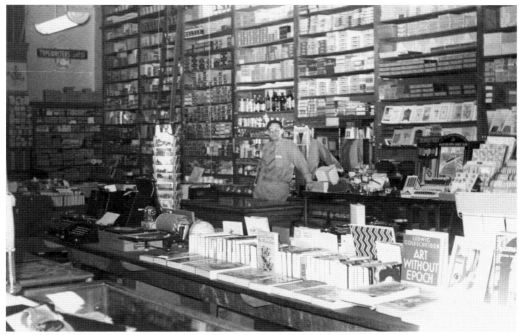

Michael Langohr
The son of German-born parents, Michael Langohr accepted a ranger position in the Gallatin National Forest in 1899. He patrolled the mountains on horseback during the week, forging trails still used today. When not wandering the mountains, Michael and his wife, Maggie, experimented with greenhouse gardening at their South Tracy Avenue home. In 1906, Michael resigned as forest ranger and expanded the family greenhouse operation, hired additional employees, and purchased a new store on Main Street. Michael Langohr passed away in 1935, but Langohr's Flowerland is still in business today.

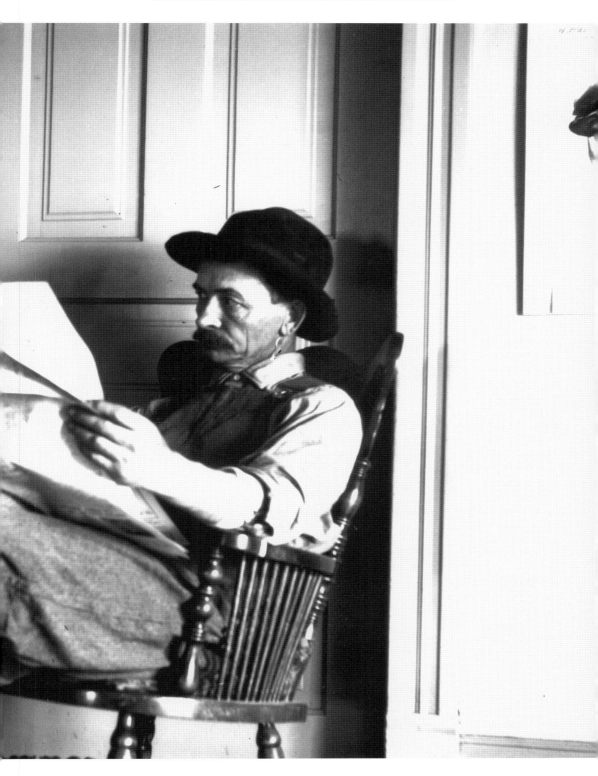

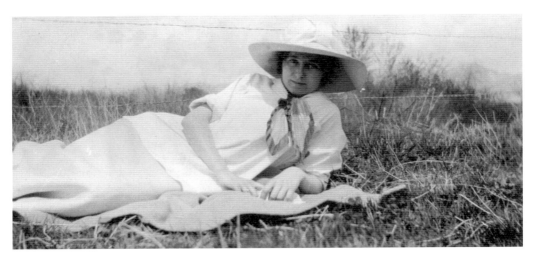

Minnie Preston

Minnie Preston owned and operated the Chambers-Fisher Department Store on Main Street for over 40 years, serving as company president from 1955 to 1985. In addition to her store and its employees, Minnie loved animals. In the 1960s, she remodeled Chambers-Fisher's storefront, taking the opportunity to add a drinking fountain for dogs near the front door. Chambers-Fisher also contained Bozeman's one and only escalator, a modern marvel enjoyed by scores of children for decades. Preston advocated support for downtown businesses while witnessing dramatic city growth that brought in national retail chains. After her death in 1998 at age 105, the *Bozeman Daily Chronicle* interviewed one of her friends, who remembered Minnie's first visit to Kmart. According to her comrade, Minnie emerged impressed, commenting, "Well, no wonder people come here." Her Kmart awe aside, Minnie sparked a push to buy local that continues today.

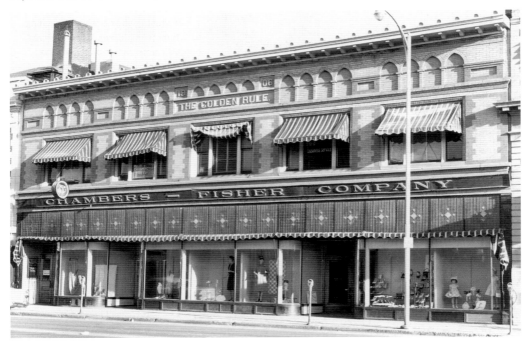

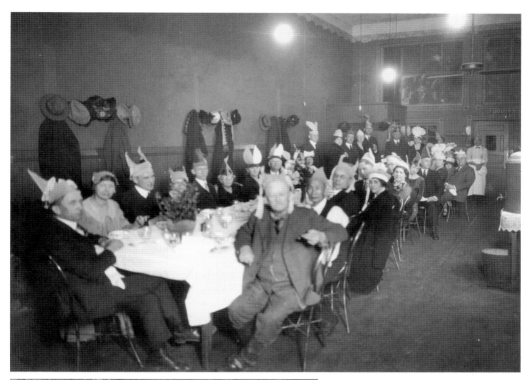

Chin-Au-Ban

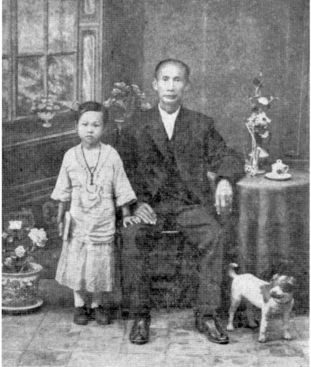

In 1921, restaurant owner Chin-Au-Ban served a farewell banquet to his local friends before returning to China (see above). Chin-Au-Ban owned the International Café on Main Street, but little is known about his personal life. According to a 1947 *Bozeman Courier* newspaper article, Chin-Au-Ban was well respected, "a solid citizen always taking a part in the better business interests of the city." The article noted the banquet's huge success. Chin-Au-Ban welcomed guests with hand-lettered name cards and treated them to two meals, one Chinese and one American. As the article recounted, "The male section unleashed their belts two notches."

Audrey Anderson
Bozeman's favorite red-haired restaurant owner Audrey Anderson grew up in an orphanage in Twin Bridges, Montana. She worked as a telephone operator before marrying her first husband, who died after an accident on their honeymoon. In 1960, Audrey moved to Bozeman and purchased the only locally-owned pizza place. Over the next 30 years, Audrey's Pizza Oven employed scores of young people and provided a venue for hundreds of first dates. Anderson's tough-love management style made her a substitute parent for many kids. Loyalty to Audrey pried sleepy employees from their beds on freezing winter nights when customers needed a pizza delivered. She still tossed pizza dough in the air at age 88, but Audrey's Pizza Oven closed in 1990. In 2010, however, the restaurant reopened, reviving Audrey's original recipes and putting her pizza boards to use once again. (Courtesy of Steve Schlegel.)

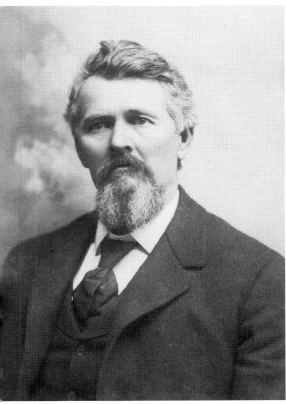

James E. Martin

Bozeman businessman James E. Martin farmed in the Gallatin Valley and operated a successful cattle ranch along the Shields River before moving his family into Bozeman, where his career quickly expanded. He cashiered at the Gallatin Valley National Bank, presided over the Bozeman Milling Company, and served three terms in the state legislature. The Martin family's large family home on South Grand Avenue remains a community landmark.

E.J. Owenhouse

Bozeman mainstay Owenhouse Ace Hardware hails from humble beginnings and hard work. In the 1880s, leatherworker Emanuel James "E.J." Owenhouse repaired saddles for the US Cavalry at Fort Ellis; he eventually partnered with Frank Benepe in his hardware business. Now known as Owenhouse Ace Hardware, the family-oriented enterprise has been run by fathers and sons (of several different families, including Spain, Williamson, and Fisher) for over 120 years. E.J. Owenhouse spent 28 years at the company before retiring in 1918.

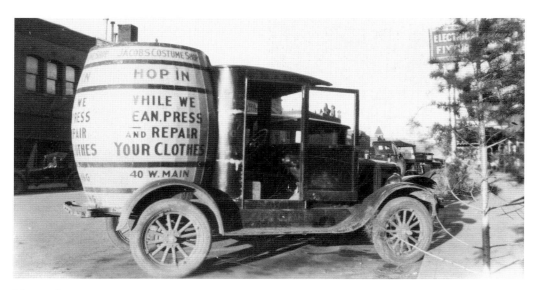

Henry Jacobs

Few businesses—past or present—can match the advertising genius of this Henry Jacobs's head-turning delivery truck. An oversized barrel invited patrons to "Hop in while we clean, press, and repair your clothes." Jacobs's humor served him well—his career in the laundry and clothing sales business lasted for more than 50 years. In addition to creating his unique mode of motorized transportation, Jacobs also excelled as a trick bicycle rider. He died in Bozeman in 1958.

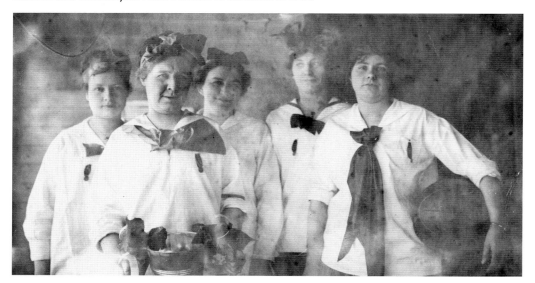

Mabel Cruickshank

In 1936, quiet, hardworking Mabel Cruickshank (shown here second from left) was elected to the state legislature—the first female legislator from Gallatin County. According to a 1989 *Bozeman Daily Chronicle* article, "The Mystery of Mabel," Cruickshank did not advertise her campaign in the newspaper like other candidates but relied on the support of local organizations like the Bozeman Women's Club. During her career, she sponsored an adult education bill in the state legislature and advocated a new zoning commission in Bozeman.

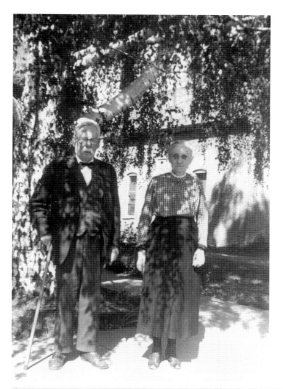

James Forristell

Irish grocer James Forristell (shown here with his wife, Augusta) immigrated to the United States at the tender age of 17. In 1875, he began an active career with the US military and was assigned to the Second Cavalry stationed in Wyoming. Besides helping to bury Custer's men at Little Bighorn, Forristell was on hand during the famous Nez Perce flight through Montana in 1877. A transfer to Fort Ellis in 1879 brought him to Bozeman, and after his discharge, Forristell stuck around and returned to the grocery business. He owned and operated Forristell Cash Grocery on East Main Street beginning in the 1890s. A "Forristell's" ghost sign, a lasting testament to his memory, remained on the side of his grocery building for decades after the business closed in the early 1940s. The natural-gas explosion in downtown Bozeman in March 2009 unfortunately erased all traces of Forristell's grocery enterprise.

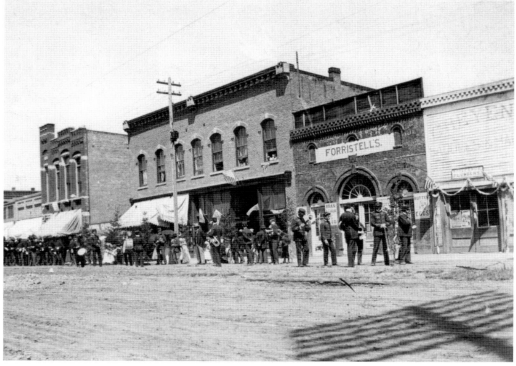

Louisa Cousselle
According to her 1886 obituary in the *Avant Courier* newspaper, Louisa Cousselle, or "Big Lou," was born in Great Britain. After traveling to Bozeman in the early 1870s, she quickly established herself as a highly successful madam, owning multiple local properties and a large mansion in New York. For several decades, prostitution was a big business in Bozeman, and a thriving red-light district operated just north of East Main Street (some of Bozeman's former red-light district cribs are pictured here). Madams like Cousselle contributed to the economy by arranging loans for Bozeman citizens and financing new development. She also provided early Bozeman doctors with a hospital, and her obituary described her as "kindhearted and benevolent," though few details about her personal life are known. Sadly, she died in 1886, likely of a drug overdose. Her body was transported back to New York, where she was buried at Green-Wood Cemetery in Brooklyn. (Photograph by Emily Marks.)

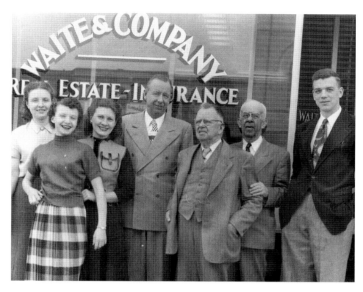

Gardner C. "Pete" Waite

Popular Bozeman businessman and philanthropist Gardner C. "Pete" Waite (fourth from left) was born in Bozeman to a pioneer family in 1908. After college and naval service in World War II, Gardner took over the family insurance and real estate business in downtown Bozeman. Waite and Company spent over 100 years on Main Street, where the store window often showcased model covered wagons. An incredibly generous man, Waite established the Gardner C. Waite Foundation in the late 1980s to financially assist organizations and charities in the Bozeman area. In 1996, the east gate on the Montana State University campus was christened the Gardner C. "Pete" Waite gate (below) in honor of his support for his alma mater.

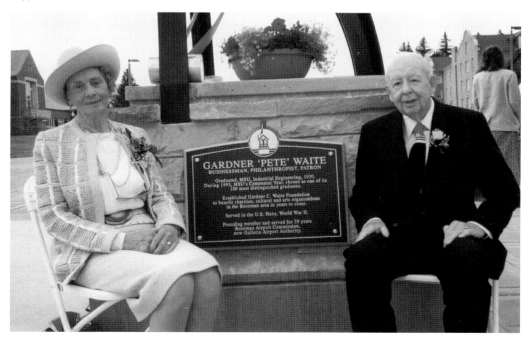

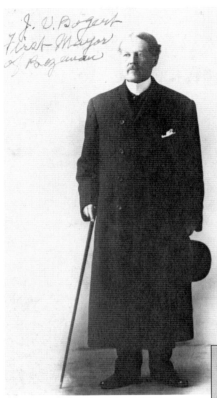

J. V. Bogert
First Mayor
of Bozeman

John V. Bogert

The city of Bozeman incorporated on March 26, 1883, and John V. Bogert was elected the city's enthusiastic first mayor. A New Yorker by birth, Bogert started working for the US Land Office in Bozeman in the early 1870s. After gaining experience in civic affairs, Bogert established a short-lived newspaper and helped organize the Yellowstone Wagon Road and Prospecting Expedition of 1874. As mayor, however, he found his true calling. From his first political speech, it was evident that Bogert planned to implement order and improve quality of life. The new city leader and his aldermen immediately began passing ordinances regulating everything from business signs to swearing in public places. Elected mayor for several terms, Bogert also initiated creation of a fire department and increased public health and safety standards. Though not authenticated, this note supposedly signed by Bogert matches his character.

OFFICE OF
THE MAYOR
CITY OF BOZEMAN

NOTICE!!

Nov 16, 1889

SMOKING
IS EXPRESSLY PROHIBITED.
IN THIS BUILDING.
No PERSONS BEING
EXCEPTED

J. V. BOGERT
MAYOR

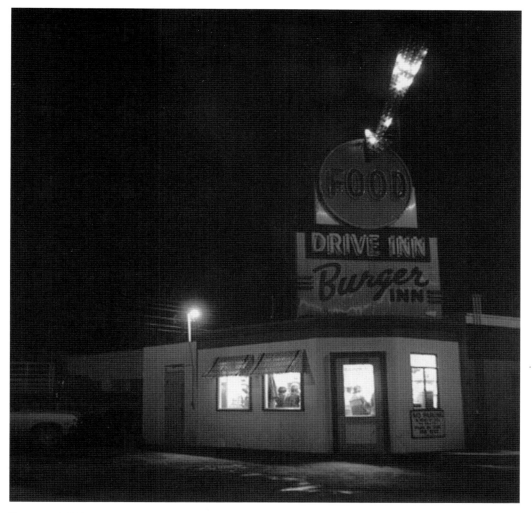

Emanuel "Manny" Voulkos
Starving college students fell in love with Manny Voulkos, owner of the Burger Inn diner. Inability to pay for one's meal was never an issue with Manny, who allowed diners to work off their tab, if need be. "Manny's," as the Burger Inn was affectionately called, was adored for its greasy comfort food, active jukebox, and inexpensive prices. In a 1995 article in the *Bozeman Daily Chronicle* titled "Memories of Manny: Big-hearted Diner Owner Dies at 70," community members reflected on their experiences with Manny and his restaurant. According to the article, "'He wasn't known for his culinary skills or special dishes,' and 'he may have actually invented cholesterol.' . . . Voulkos 'had a philosophy that if you smiled first thing in the morning you got over it for the rest of the day.'" (Photograph by Steve Jackson; courtesy of Daniel Voulkos.)

Mary Jane Di Santi

"I used to say the bookstore was like my fifth child, and it was the one that was always the problem. It'd get more attention than anything." Mary Jane Di Santi, 36-year owner of Bozeman's iconic bookstore, the Country Bookshelf, became a business owner at the tender age of 24. A local book lover, she had admired the little shop since childhood, and the day she took ownership was a dream come true.

The future Country Bookshelf first opened its doors in 1957 under owner Polly Renne, wife of Montana State University president Roland Renne. The store's second owner, Marguerite Kirk, rescued Bozeman's first Catholic church building, a little white chapel, and moved it to her family property along West Babcock. The small church, with its rich history and loft balconies, was a perfect bookstore setting. Fresh out of college, Di Santi rented a makeshift apartment (which she affectionately calls "the tool shed") directly next door to the bookstore. Since she lived in close proximity to the business, Mary Jane landed her dream job at the shop and almost immediately began trying to purchase the store. Her persistence paid off. Despite Kirk's concern that Di Santi would not "stick with it," Mary Jane and a friend won her over and took ownership in 1974. Twelve years later, Country Bookshelf expanded to a larger building in the heart of historic downtown Bozeman, where Mary Jane designed a second-floor balcony to add display space. The additional elevated square footage also paid homage to the store's previous layout in the old Catholic chapel, a nod to the store's humble beginnings.

In 2010, Di Santi sold Country Bookshelf to a dedicated employee. She now spends her time working for Gallatin County, spending time with grandchildren, and reading the books in her extensive personal collection—books that she did not have time to crack open as a busy business owner. Thanks to hard work and a business philosophy that encouraged reinvesting profits back into the business, Country Bookshelf is now a nationally known bookstore. Though Di Santi is living a slightly less hectic life nowadays, she treasures her memories and still keeps in touch with authors and customers. (Photograph by Emily Marks.)

Henry Pease

In 1864, Henry Pease and his family left the Civil War conflict behind in Missouri for a new life in Montana Territory. Trained as a jeweler, Pease worked in Virginia City for 18 years before moving his business to Bozeman in 1882. Pease Jewelry Store eventually passed to Henry's grandson Claude Steffens, who sold the business to Harry Miller in 1945. Now called Miller's Jewelry, the store is still located at the corner of Main Street and Tracy Avenue. It remains one of Montana's oldest jewelry stores.

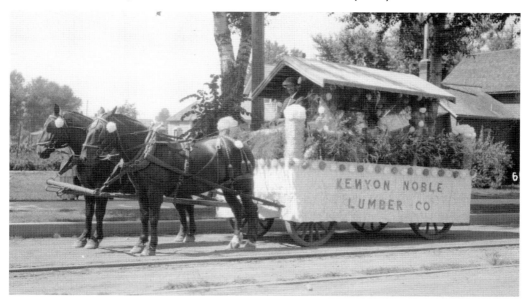

Squire C. Kenyon

Capitalizing on Bozeman's 1890s building boom, Squire C. Kenyon purchased a financially troubled lumber operation and moved it to Bozeman. In 1906, the respected business incorporated under owners Squire Kenyon, Carlisle Kenyon, and Thomas Noble. Squire Kenyon died in 1929, but his business is still expanding. With several locations around the Gallatin Valley, including the new Bozeman store (completed in 2006), Kenyon-Noble Lumber and Hardware is still synonymous with quality, customer service, and local pride.

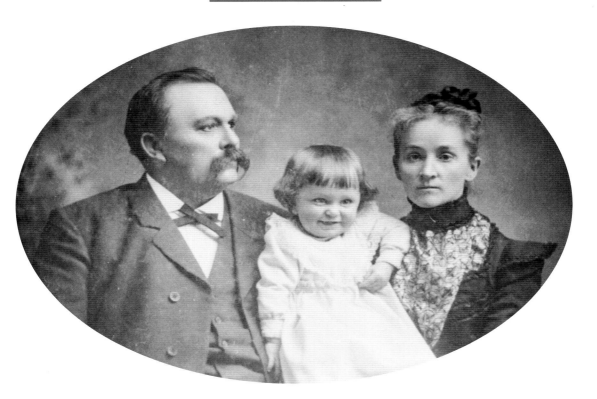

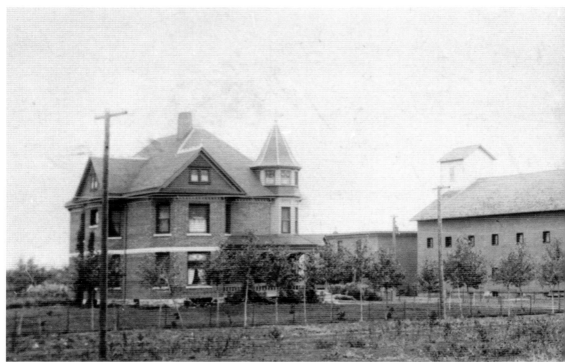

Julius Lehrkind

German immigrant Julius Lehrkind (at upper left with his second wife, Lena, and son Herman), a Bozeman beer magnate, learned his craft working for breweries in the Midwestern United States before opening his own enterprise in Iowa in the late 1860s. In the 1890s, the Gallatin Valley's reputation as fantastic barley-growing country, along with its abundance of clear water, began to attract brewers like Lehrkind. Julius, sensing an opportunity, moved his wife and kids to Bozeman and bought out local brewers Jacob Spieth and Charles Krug. Lehrkind's Lager Beer Brewery expanded to the northeastern edge of town, where its proximity to the railroad tracks facilitated incoming and outgoing shipping. Lehrkind's brewing company proved successful, and he constructed a massive brick brewery building (interior view pictured above) and a palatial private mansion on North Wallace Avenue (mansion and brewery pictured below). Julius died in 1922 during the early years of Prohibition, when large breweries disappeared and bootleggers stepped in to fill the void. In a smart business move, the Lehrkind family adapted to the times and diversified, branching into ice, coal, ice cream, and soft drink sales. The last remnants of the large brick Lehrkind brewing plant were removed in 2014, but the family-run business still enjoys success as a bottling company.

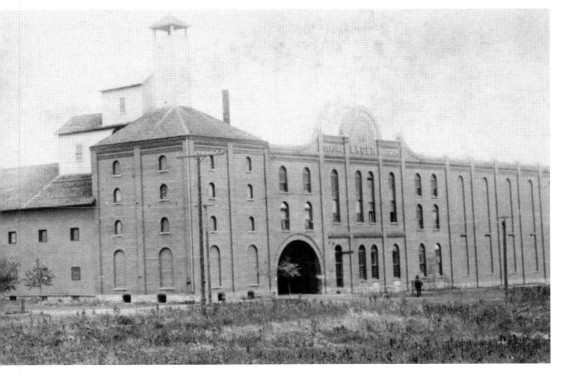

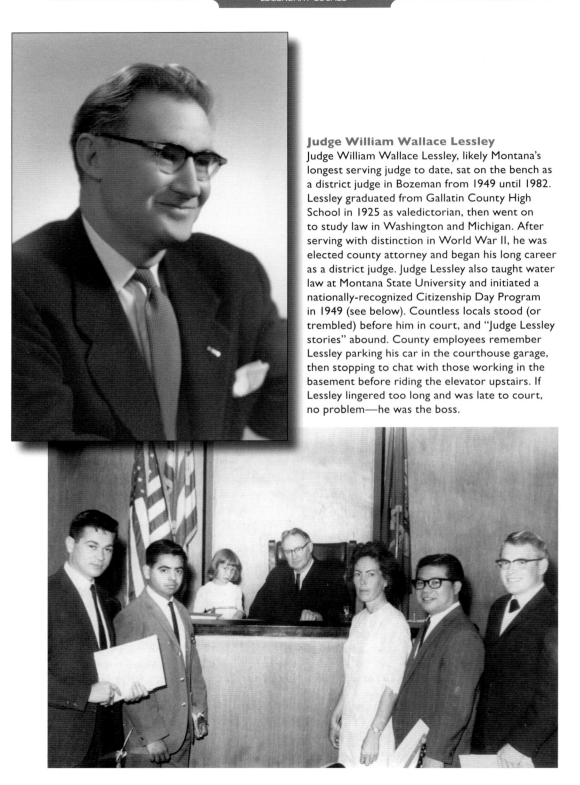

Judge William Wallace Lessley

Judge William Wallace Lessley, likely Montana's longest serving judge to date, sat on the bench as a district judge in Bozeman from 1949 until 1982. Lessley graduated from Gallatin County High School in 1925 as valedictorian, then went on to study law in Washington and Michigan. After serving with distinction in World War II, he was elected county attorney and began his long career as a district judge. Judge Lessley also taught water law at Montana State University and initiated a nationally-recognized Citizenship Day Program in 1949 (see below). Countless locals stood (or trembled) before him in court, and "Judge Lessley stories" abound. County employees remember Lessley parking his car in the courthouse garage, then stopping to chat with those working in the basement before riding the elevator upstairs. If Lessley lingered too long and was late to court, no problem—he was the boss.

CHAPTER THREE

Educators, Intellectuals, and Scientists

Almost as soon as Bozeman's first log cabins were built, children started school. In 1865, young scholars attended class in the back of a local store, but as the town grew, so did the number of pupils. Makeshift classrooms moved from building to building, occupying churches, cabins, and shops. The first brick schoolhouse was constructed in 1877 on present-day West Babcock Street. A second grade school was added in 1883. A new Gallatin County High School building appeared in 1902, closely followed by a third elementary school.

During Bozeman's 150-year educational history, dedicated teachers have set high standards of learning while emphasizing kindness, generosity, and integrity. Ida Davis likely had one of the longest teaching careers in Bozeman history, instructing her pupils in English and math for nearly 50 years. She also deserves some credit for the future success of actor Gary Cooper—in 1922, she persuaded him to take his first acting role in the senior class play. Likewise, teacher and former Bozeman High School principal Godfrey Saunders has cared for students in a similar fashion. Confident in and proud of today's young people, Saunders looks with hope to the future and still radiates positive energy through his continued involvement in education.

Throughout its long history, Montana State University has also contributed to a civic emphasis on learning while drawing talented scientists and educators to the area. Established in February 1893 by the Montana Legislature, the brand-new land-grant school was first called the Agricultural College of the State of Montana. By 1913, the college was referred to in school publications as Montana College of Agriculture and Mechanic Arts. In the early 20th century, most knew the school as Montana Agricultural College (or MAC), and in 1921 Montana State College became the official moniker. The Montana State Legislature formally adopted the name Montana State University in 1965.

In 1893, Bozeman businessman Peter Koch shaped the infant land-grant college, intent on hiring instructors who were passionate about teaching. Dr. Merrill Burlingame dominated the history department and became one of the foremost experts on Bozeman and Montana history. Longtime popular professor and Native American studies scholar Dr. Walter C. Fleming is the author of several books, including the popular *Complete Idiot's Guide to Native American History*.

Bozeman is also no stranger to cutting-edge scientific advancements and discoveries. In 1893, physician Henry Foster successfully performed one of the first Cesarean sections in Montana, astonishing both patients and colleagues. James Henshall served as the first superintendent of the government-formed Bozeman National Fish Hatchery in nearby Bridger Canyon. His studies of native and non-native species of fish in Montana began as a result of local concern with declining fish populations in the 1890s. Research into fish conservation, habitat, and behavior continues at the same institution, now called the Bozeman Fish Cultural Development Center. For solar physicist and astronaut Loren Acton, science is a "never-ending source of pleasure." After flying in space in 1985, Loren dove into his passion: solar research. He has served on boards for several community organizations and even campaigned for a seat in the Montana House of Representatives.

With record enrollments at Montana State University and an emphasis on quality education, Bozeman will no doubt continue to attract phenomenal teachers, sparking new ideas and cutting-edge research in the fields of education, science, engineering, and many more.

Walter C. Fleming

"Well, there's a saying that you teach best what you most need to learn . . . I've always thought that was what motivated me." A pillar in the Native American Studies department at Montana State University since 1979, Fleming was born in Crow Agency, Montana. He grew up on the Northern Cheyenne Reservation and studied education at Dawson Community College and Montana State University–Billings. In the mid-1970s, he emerged at the forefront of a brand-new discipline in Montana: Native American studies. After teaching a summer class in the subject at MSU, he finished graduate school and joined the faculty. In 2003, as the direct result of his work on an online "ask an expert" column on Native American history and culture, he authored the book *The Complete Idiot's Guide to Native American History.* (Courtesy of Walter C. Fleming.)

Florence Ballinger Hamilton
Florence Ballinger was born in Missouri in 1873 and came to Montana as a child. The family settled on a ranch in the Paradise Valley, where their proximity to Yellowstone provided enticing opportunities for adventure. During one trip to the park, her brother raced the family wagon past a coach intended for Pres. Chester Arthur, irritating the accompanying soldiers but creating a cherished Ballinger memory. She attended college in Missouri before enrolling at Montana State College to study art (she is pictured above as a model) and domestic science. Florence played for the school's first women's basketball team, and in a 1970 *Bozeman Daily Chronicle* article, she recalled their uniforms of bloomers and middy blouses. She went on to teach at Montana State for 18 years and married college president James Hamilton in 1918. The couple is shown here in 1939. (Left, courtesy of Montana State University Special Collections.)

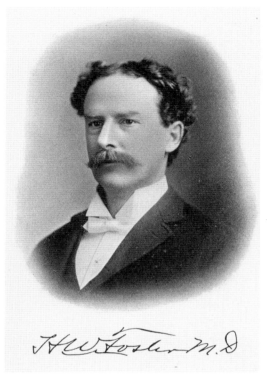

Dr. Henry Foster

Minnesota-born Dr. Henry Foster arrived in Bozeman in 1882 at the young age of 24, already a trained surgeon. Cesarean sections were virtually unheard of in Montana in the 1890s, but the confident Dr. Foster performed one safely in Bozeman in 1893; it was likely the first such procedure in the state. After a second successful C-section three years later, Foster quickly gained notoriety in his field. Accounts of the procedures in medical journals amazed practitioners in the eastern United States, who could not imagine performing such a surgery away from modern facilities. Dr. Foster's small practice began bursting at the seams as new patients from across the region sought his care. In 1896, Foster constructed a grand-looking hospital (pictured below), located on the corner of Lamme Street and Tracy Avenue, capable of housing 20 patients. The hospital boasted hot water and electricity, along with colorful wall and ceiling frescoes.

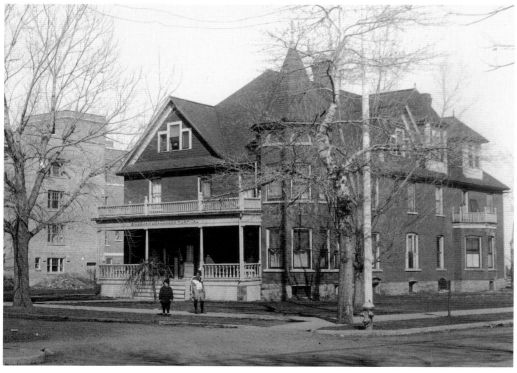

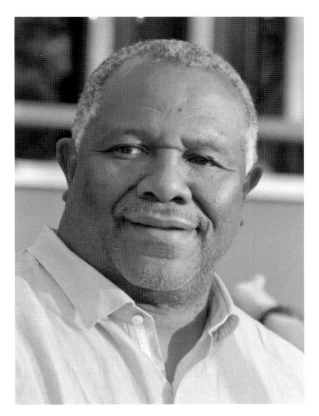

Godfrey Saunders

At age 17, Godfrey Saunders stepped off the bus in Dillon, Montana, wearing zebra-striped pants. "You didn't see too many men in pink suits or powder blue suits in Dillon," he laughs as he remembers his southern Florida style. Growing up in the south, Godfrey remembers poring over his dad's *Field and Stream* magazines and sharing his Bahamian father's dream of one day seeing mountains. After witnessing riots during his senior year in 1971 at his hometown's first integrated high school, Saunders followed the advice of his mother and left Florida. He chose Western Montana College in Dillon over the Naval Academy thanks to those *Field and Stream* magazines. After enduring his own difficult high school experiences, he decided to become an educator to protect students from facing the hardships he experienced in his youth and to make school a positive experience for students, faculty, and staff.

In 1983, after college and a few years in Oregon, Saunders returned to Bozeman and was hired for a teaching and coaching job at Bozeman High School. In 1996, he accepted the job as school administrator and served as one of Bozeman High's most admired principals until 2009. Godfrey is quick to relate that his favorite part of his career was working with students and having a positive influence on the lives of so many. He strives to give young people the credit they deserve, saying, "I don't have the same fears and dread that a lot of people do. I don't fear growing old in America. I really don't, especially in Montana because of what I've seen. Young people still care."

Godfrey Saunders now spends his time as an adjunct professor at Montana State University and shares his talents in several mentoring programs across the state. Grandchildren, outdoor activities, and antique firearms take up the rest of his spare time. He still keeps in touch with many of his former students, which number in the thousands. Young adults in Bozeman and across the nation excitedly yell "Mr. Saunders!" when they see him on the street, and letters from former students bring tears to his eyes. As he relates, "I just want to give back. So many people went out of their way to help me . . . my answer lies with kids." (Courtesy of Godfrey Saunders.)

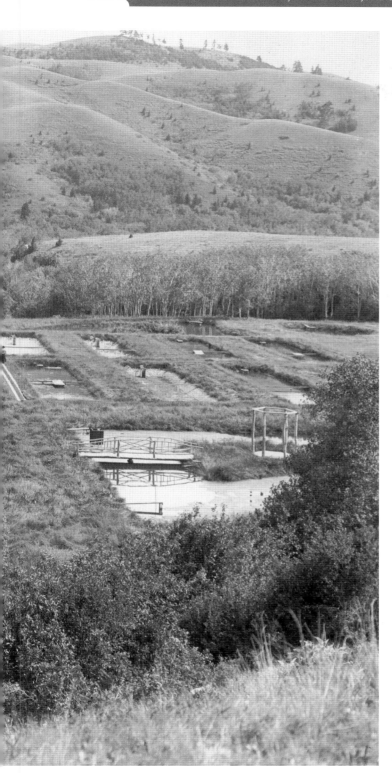

Dr. James Henshall
In 1893, concern about effects of intensive mining and logging activities on Montana fish populations prompted the federal government to establish a hatchery and research facility in Bridger Canyon. Led by Supt. Dr. James Henshall, the Bozeman National Fish Hatchery (shown here) studied native Montana trout and bred fish to supply locations throughout Montana. The site in Bridger Canyon proved an ideal location for the operation due to an abundance of water and natural springs of varied temperatures. Now called the Bozeman Fish Cultural Development Center, the institution remains one of the oldest operations of its kind in the Northwest.

Loren Acton

On July 29, 1985, after seven years and almost as many delays, payload specialist Loren Acton and his fellow crewmembers of Spacelab 2 finally launched into orbit aboard the Space Shuttle *Challenger*. Loren grew up in Lewistown and Billings, Montana, where he discovered an affinity for mechanical engineering. He studied physics at Montana State University and received his PhD in Astro Geophysics in Colorado before working for 29 years at the Lockheed Palo Alto Research Laboratory. Acton's career included NASA-funded research contracts and his eight-day experience in space aboard the *Challenger* (he was sick for four of those days). Indulging his "never-ending source of pleasure" studying the sun, Acton worked on an international solar imaging satellite project in Japan before returning to Bozeman in 1993. In addition to expanding solar physics studies at Montana State University, Acton ran for public office in 2006 and remains active in the Bozeman community. (Courtesy of Loren Acton.)

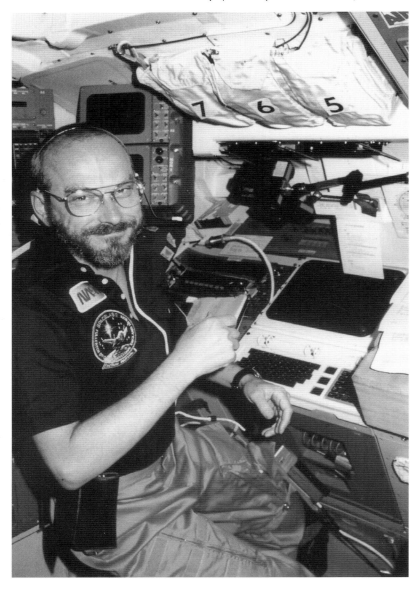

Ida Davis

In December 1962, a letter by Judge William Wallace Lessley printed in the *Bozeman Daily Chronicle* eulogized teacher Ida Davis as "a very little lady. But she stood tall and strong in the minds and hearts of hundreds of her former students." Davis came to Bozeman in 1903 from Missouri and spent most of the next 47 years teaching English and math at Gallatin County High School. She also served nine years as Gallatin County Superintendent of Schools and taught summer education courses at Montana State College. Davis was remembered as a fantastic teacher, but more importantly, she viewed every student as special and treated them accordingly. Perhaps her most famous pupil was movie star Gary Cooper, who made it a point to visit her each time he returned to Bozeman.

Bertha Clow

Trained nutritionist Bertha Clow came to Bozeman from Wisconsin in 1929 to join the faculty at Montana State College and taught nutrition in the home economics department for the next 40 years. Besides teaching, Bertha enjoyed consulting with local organizations and writing newspaper columns. Weaving together her love of history and nutrition, Clow transformed early native and pioneer recipes, diets, home remedies, and even holiday dinners into articles and books. A talented photographer, Clow was a dedicated member of the Bozeman Camera Club. She and her fellow club members captured iconic images (like the wagon below) around Montana and Gallatin County during the country's bicentennial in 1976. Bertha passed away in 2004 at age 101.

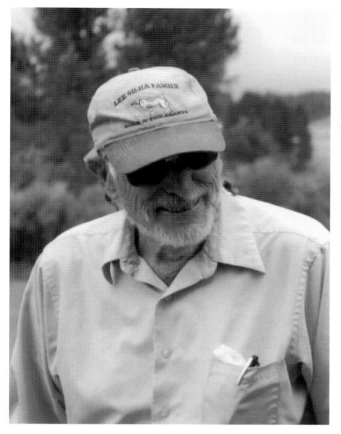

Dr. Volney Steele

In Dr. Volney Steele's pathology laboratory on the top floor of the old Bozeman Deaconess Hospital, one could usually find a box of doughnuts. In his words, "I had to bribe these doctors . . . the laboratory is the last place a doctor would think of going visiting, but this way it kind of brought them in there to talk." The pastries worked. Doctors dropped by during rounds, Dr. Steele would look up from his microscope, and everyone sat down to chat and eat doughnuts.

The son of a physician, Volney Steele grew up in Arkansas listening to his father's stories, which sparked his desire to practice medicine. Volney graduated from medical school in Arkansas and served in the Navy during World War II. After a brief return to civilian life, in 1950, he was called back into service during the Korean War. Remaining stateside, Dr. Steele worked at a recruiting office, performing exams on healthy new recruits and longing for more of a challenge.

Following a brief stint at a Navy hospital in Jacksonville, Florida, Steele moved to Colorado and went into general practice. According to Dr. Steele, in those days it was easy to get a job practicing medicine. Even though his medical license was issued in Arkansas, the only job requirements were a signature and an interview. After two years in Colorado, he returned to school to pursue specialized training in pathology and jumped at the chance to complete a residency at a hospital near the Panama Canal. This proved a fascinating opportunity for Dr. Steele, because, in his words, "they had everything (tropical diseases), from a pathological standpoint."

In 1959, a doctor in Butte, Montana urged Dr. Steele to move north and become his partner. During a preliminary visit, Dr. Steele befriended several Bozeman doctors who convinced him to move to the Gallatin Valley instead, much to the Butte doctor's disappointment. The first pathologist in town with a laboratory, Dr. Steele spent the rest of his professional career in Bozeman, studying pathology and handing out doughnuts. After retiring from practice, he turned his attention to his other great passions: writing, fishing, and assisting returning veterans. In 2007, Volney Steele, along with retired Marine colonel Eric Hastings and several others, established Warriors and Quiet Waters, an organization dedicated to providing peace to combat veterans through fly-fishing trips in Montana. Steele wrote two books: a biography of Wellington Rankin and a history of medicine on the Western frontier, *Bleed, Blister, and Purge*. (Courtesy of Warriors and Quiet Waters.)

E. Augusta Ariss

Though only a brief resident of Bozeman, E. Augusta Ariss left an indelible mark on local medicine. Ariss left Toronto to work in a Methodist mission in Montana and soon found herself the superintendent of the Great Falls Deaconess Hospital. She came to Bozeman in 1911 and used her management skills to transform Dr. Henry Foster's old, financially struggling Bozeman Sanitarium into a modern and efficient hospital. As superintendent, she also established a nursing school on site that provided both instruction and boarding. Ariss left Bozeman in 1914, but the nursing school and hospital continued to grow. In 1920, a new Bozeman Deaconess Hospital was constructed just west of the old sanitarium. After being repurposed as a nursing residence and training school, the original Bozeman Sanitarium building (below) was utilized until 1952.

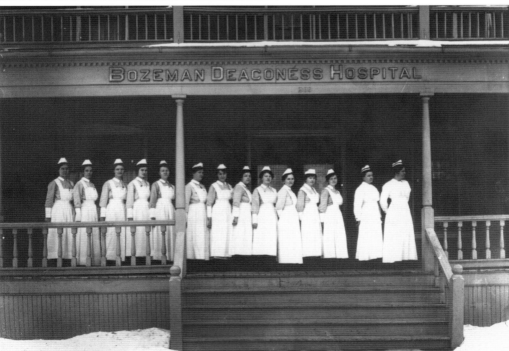

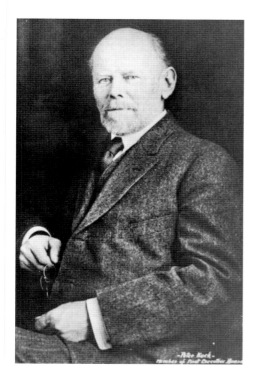

Peter Koch

Bozeman banker and Danish immigrant Peter Koch was arguably the biggest driving force behind the creation and lasting success of Bozeman's land-grant college, Montana State College of Agriculture and Mechanic Arts, which was established in 1893. After lining up an initial budget and course catalog, Koch advocated hiring dedicated instructors excited about learning. While his opinions clashed with other educational views of the day, Koch's vision emerged victorious, and the college flourished as a result.

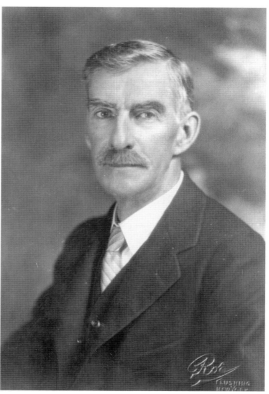

Augustus M. Ryon

Augustus M. Ryon became the first president of Montana State College of Agriculture and Mechanic Arts in the summer of 1893. As an experienced engineering instructor, Ryon's first task was building a functioning agricultural experiment station. This involved the construction of Taylor Hall, now the oldest existing building on campus. Most importantly, Ryon planted the seeds of the top-notch engineering program that students enjoy today.

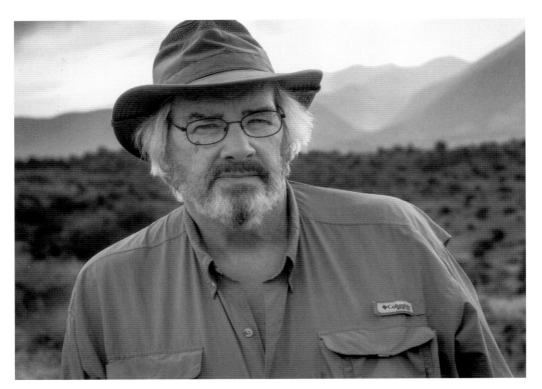

Jack Horner

For as long as he can remember, Jack Horner has loved wandering around Montana, searching for buried treasure—prehistoric fossils, that is—and, according to Horner, he was born for the task. The Shelby, Montana, native spent the majority of his childhood exploring nearby hills and collecting specimens along Montana's highline. Dyslexia made school difficult for Jack; nevertheless, science became his passion. Science fairs offered him a constructive outlet, and he won nearly every competition he entered. In high school, his paleontology projects attracted the attention of the geology department at the University of Montana in Missoula. After graduation, he enrolled as a geology major but struggled academically. After two years in the US Marine Corps during the Vietnam War, Horner returned to school in Missoula. He never completed his bachelor's degree but did finish a thesis, proving his passion for his chosen field.

Fascinated by paleontology, Horner applied for positions around the world (anywhere they spoke English), and in 1975 he was rewarded with a job as a technician in the Paleontology Department at Princeton University. After two years, his work caught the attention of his supervisor, and he was promoted to assistant curator.

In 1978, while back in Montana enjoying his old pastime of wandering the hills and searching the ground, Horner discovered baby dinosaur fossils. His find made news across the globe, and Princeton promoted him again, this time to research scientist. More field work and discoveries followed, and by 1982, Horner permanently returned to Montana to become curator of paleontology at the Museum of the Rockies in Bozeman. Starting from scratch, he built a paleontology program and fossil collection that rivals any other on earth.

Horner's research primarily focuses on dinosaur growth, behavior, and evolution, and his notoriety in the field of paleontology has led to some interesting opportunities. He is well known for his consulting work on Steven Spielberg's Jurassic Park films, for which he lent his expertise to the realistic use of animatronic dinosaurs on set. When not busy with research or teaching, Jack still scours the earth for dinosaur fossils. As he explains, "even if it's a dinosaur I have found a hundred times before, it's just as exciting as the very first one I ever found." (Courtesy of Kelly Gorham.)

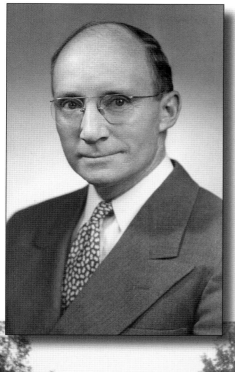

Dr. Merrill Burlingame

Affectionately called "Mr. Montana History" in a 1985 article—"'Mr. Montana History' still learning at 84," by Kim Brown—in the *Bozeman Daily Chronicle*, Dr. Merrill Burlingame probably knew more about the subject than anyone else before or since. Originally from Iowa, Burlingame came to teach history at Montana State College in 1929. The ever-humble professor spent decades writing, collecting, and storing Montana's history. In 1941, Burlingame's decade of research on John Bozeman culminated with his publication of a short biography, *John M. Bozeman, Montana Trailmaker*, which remains the go-to reference on John Bozeman to this day. Before his death in 1994, Burlingame authored dozens of articles and books on Montana history, and his guidance was instrumental in the creation of both the Gallatin History Museum (formerly the Pioneer Museum), and the Museum of the Rockies (formerly the McGill Museum). Dr. Burlingame is shown below in his later years, poking around a historic Gallatin County building.

Eleanor Buzalsky

Eleanor Buzalsky, or "Buzz," grew up in North Dakota, where she began teaching right out of high school. Her brief marriage to Edward Buzalsky began just before World War II, where Edward was tragically killed in 1944 while serving as a tank commander in Belgium. Eleanor never had children, but after 38 years of teaching and coaching, she always said "she had lots of children." Beginning in 1953, she taught physical education at Bozeman Senior High School for 30 years, coaching generations of Bozeman teenagers. Even in retirement, she never lost her passion for sports and religiously cheered on local high school and college athletes. The author fondly remembers Eleanor listening to Montana State University football games on the radio while working on genealogy projects at the Pioneer Museum (now the Gallatin History Museum). "Buzz" passed away in 2008 at age 87.

CHAPTER FOUR

Athletes and Outdoor Enthusiasts

During the winter of 1928–1929, basketball fans sat enthralled as one of the most incredible sports teams in Montana history dribbled and shot their way to an almost unheard of 36 wins, not to mention a national championship. The Golden Bobcats of Montana State College only lost one game that season, and few teams have matched—or will ever match—their success.

Other team sports, like women's softball and basketball, got an early start in Bozeman. In the 1930s, members of the Bridger Club Women's softball team crisscrossed southwest Montana in a truck, traveling to games and enjoying bubble gum during the drive. The 1908 Gallatin County high school girls' basketball team persevered and won the state championship despite wearing cumbersome wool bloomers as uniforms.

Individual football players like Jan Stenerud, Sonny Holland, and Mike McLeod broke school records and went on to enjoy successful careers on and off the gridiron. The legendary 1940–1941 Montana State College football team fought hard on the field but gave the ultimate sacrifice in World War II, when at least 13 star players left home to fight and never returned.

During Bozeman's infant years—before organized, indoor sports like basketball—locals relished outdoor activities and admired friends and neighbors with impressive athletic abilities. Today, during the summer months, one can frequently see cyclists on area roads or Subarus laden with mountain bikes headed for alpine trails. Few may realize that even at the start of the 20th century, a bicycle craze existed in Bozeman. In 1901, cyclist William Ginn edged out fierce competition in Bozeman's annual Fourth of July bike race, impressing local fans.

In the 1930s and 1940s, downhill skiing emerged as a popular recreational activity, and winter sport enthusiasts like Kay Widmer worked to establish local ski areas at Bear Canyon and Bridger Bowl. Olympic mogul skier Heather McPhie pushes the boundaries of her sport with ever more complex tricks, encouraging young women to face their fears and live their dreams.

Boxers, mountain climbers, and runners have also made their mark. Pugilist Hubert "Kid" Dennis found fame as a lightweight boxer during the 1930s, both in Montana and on the West Coast. Today, mountaineers and ice climbers enjoy a plethora of world-class climbing sites around Bozeman. Before his death in Tibet in 1999, local endurance athlete and climber Alex Lowe summited Bozeman-area mountains and famous peaks around the world, reaching the top of Mount Everest twice. College chemistry professor Ed Anacker became hooked on endurance bicycling and running in the 1970s. His love of running was contagious, and in 1985 Anacker started what would become a beautiful but brutal Bozeman tradition—the 20-mile Bridger Ridge Run along the crest of the mountains north of town. Whatever their sport, legendary Bozeman athletes and outdoor enthusiasts continue to amaze people, push physical boundaries, break records, and win championships.

Marga Hoseaus

Born in San Francisco in 1918, Marga Hosaeus (pictured here with Gertrude Roskie) spent most of her childhood in Germany. Beginning in 1945, following graduate school in Illinois, Hosaeus served as head of the Women's Health and Physical Education Department at Montana State College. After the men's and women's physical education departments merged, Hosaeus continued teaching at Montana State as a professor until her retirement in 1979. A new health and recreation center was constructed at Montana State University in 1984 and christened the Marga Hosaeus Health, Physical Education and Recreation Complex.

John "Brick" Breeden

In 1980, Montana State's domed indoor stadium was renamed the Brick Breeden Fieldhouse in honor of an outstanding local student athlete and coach. Famous defensive basketball player John "Brick" Breeden attended Gallatin County High School, where he excelled at football (shown below, fourth from left in the front row) and basketball. The tall, redheaded Breeden likely received his nickname either due to his hair color or his blocking abilities on the basketball court. A member of the famous "Golden Bobcats" basketball team at Montana State College, Breeden's solid defense helped his team set records in the late 1920s. After college, Breeden's diverse athletic talents transformed him into a versatile and talented coach of multiple sports. Breeden retired in 1971 after serving 17 years as head coach of Montana State's basketball team and two years as athletic director. He passed away in 1977, leaving his legendary stamp on Bobcat athletics.

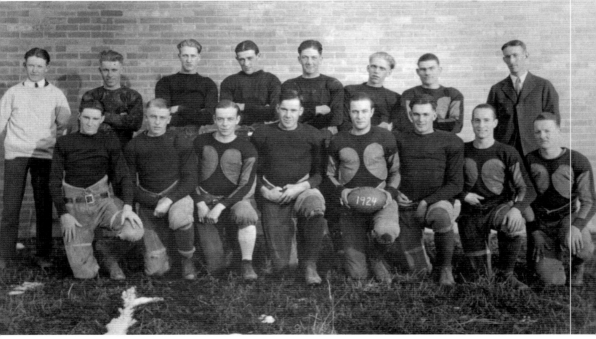

Ed Anacker

At 5:15 a.m. on an August morning in 2011, six hardy souls began a 26-mile run along the crest of the Bridger Mountains. At 7:00 a.m., they reached Fairy Lake, where they joined the last starters of the Ed Anacker Bridger Ridge Run. This extra distance on an already notoriously grueling trail race commemorated the April 3, 2011, passing of Ed Anacker, college professor and endurance athlete. It was not uncommon for Anacker, a faculty member in the Chemistry Department at Montana State, and his friends to get ice cream or coffee in Ennis or West Yellowstone—after arriving by bicycle. While easygoing Ed competed in several 100-mile footraces, cookies made by his wife, Stella, fueled local runners and achieved fame in their own right. Anacker started the Ridge Run in 1985, and it is still held each August; its popularity is a testament to Ed's contagious love of endurance sports. (Courtesy of David Summerfield.)

71

Bridger Club Women's Softball Team
The Bridger Club Women's Softball Team, shown here in the late 1930s, provided an early opportunity for women to enjoy organized sports. Second baseman Lavina Kurk Chadbourne (pictured here standing on the left) along with her sisters Mildred (standing, third from left) and Myrtle (standing, fifth from left), traveled with the team, playing other community softball squads across southwest Montana. According to Cherry Eustace, Lavina's daughter, one day the team was unable to find transportation to a game in Gardiner. Lavina's father, Arthur, obligingly drove them the 80 miles to their game in the back of a pickup truck. Arthur Kurk provided the players with bubble gum and himself with a cigar.

Mike McLeod

In 1979, senior Bobcat football player Mike McLeod intercepted a pass and returned it 89 yards for a touchdown. This broke the previous school record of 82 yards, which, ironically, was set by his father, Jim, 20 years earlier. McLeod's performance (and his relationship to the previous record-holder) turned some heads and was even discussed on Paul Harvey's national radio show.

Mike McLeod was born in Bozeman, the son of a Bobcat football player and a University of Montana cheerleader (Jim and Ardy McLeod). After a sports-filled childhood growing up in Cheyenne, Wyoming, Mike McLeod returned to Bozeman in 1976 to play for the Bobcats and his father's former teammate, coach Sonny Holland. Expecting to occupy the wide receiver position, Mike was assigned to defensive back and played as a freshman. The Bobcats won the national championship that year—the second of three times in the school's history. As a senior and a team captain, he helped lead the Bobcats to the Conference Championship in 1979.

After graduation, McLeod moved to Canada, where he played five years in the Canadian Football League for the Edmonton Eskimos. While at Edmonton, McLeod was part of three Grey Cup Championship teams (out of five in a row), and the Eskimos were named the "Team of the Century" in the Canadian Football League. McLeod completed a law degree from the University of Alberta, then returned to the United States, where he played two years for the Green Bay Packers. McLeod practiced law briefly in Madison, Wisconsin, before returning to Bozeman in 1989. Since Mike was interested in switching careers, former coach Sonny Holland stepped into his old role and passed along some guidance. Holland connected McLeod with Earl Hanson, another former Bobcat football player, and the two started Hanson and McLeod Financial Group, an insurance and financial services brokerage firm that is still in business today.

While his children grew up, McLeod enjoyed coaching them in various sports. He traveled with the Bozeman Hawk basketball teams, taking students all over America to compete in tournaments, and he helped start an Amateur Athletic Union basketball team called Montana Hoops. Currently, Mike donates his time to Christian ministries like Bible Study Fellowship and Fellowship of Christian Athletes. Thankful for all the mentors in his own life, spiritual and athletic, Mike strives "to rub off on others in that sense, too, in a positive way." (Courtesy of Mike McLeod.)

Kay Widmer

Enthusiastic skier Kay Widmer (shown here on the left) frequented downhill runs in Bear Canyon during the late 1930s and helped establish Bridger Bowl in 1954. Famous for her weekly *Bozeman Daily Chronicle* column, "Dope on the Slope," Widmer gave readers the scoop on snow-mired vehicles, ski hill courtesy, news, exploits, and wipeouts. According to her obituary in the *Bozeman Daily Chronicle* in April 2000, Widmer was proud of the fact that she "skied for 38 years without getting hurt."

Charles Bradley and John Montagne

Because of its proximity to world-class skiing opportunities, Bozeman has attracted snow scientists as well as recreational hobbyists. Beginning in the 1950s, snow experts Charles Bradley and John Montagne, along with Donald Weaver, began local studies into snow pack, snow formation, and avalanches. As more skiers flocked to the Bridger Bowl ski hill (shown below) in the 1960s, Bradley and Montagne's research led to increased safety measures and new methods of avalanche prediction.

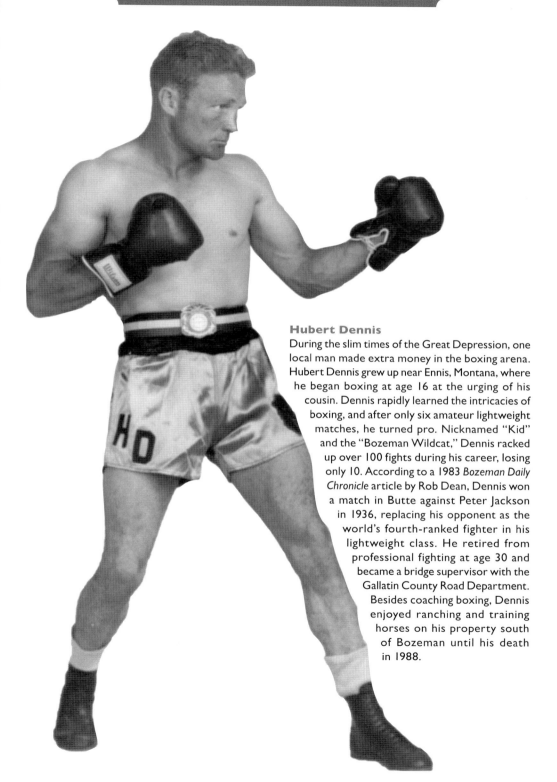

Hubert Dennis

During the slim times of the Great Depression, one local man made extra money in the boxing arena. Hubert Dennis grew up near Ennis, Montana, where he began boxing at age 16 at the urging of his cousin. Dennis rapidly learned the intricacies of boxing, and after only six amateur lightweight matches, he turned pro. Nicknamed "Kid" and the "Bozeman Wildcat," Dennis racked up over 100 fights during his career, losing only 10. According to a 1983 *Bozeman Daily Chronicle* article by Rob Dean, Dennis won a match in Butte against Peter Jackson in 1936, replacing his opponent as the world's fourth-ranked fighter in his lightweight class. He retired from professional fighting at age 30 and became a bridge supervisor with the Gallatin County Road Department. Besides coaching boxing, Dennis enjoyed ranching and training horses on his property south of Bozeman until his death in 1988.

Jan Stenerud

Norwegian-born skier Jan Stenerud came to Montana State College in the mid-1960s with the intent of competing for the college ski jumping team. By the time he left Bozeman two years later, Stenerud was a nationally-known collegiate athlete—not as a competitive skier, but as a football placekicker. Stenerud's ability was discovered by accident when Montana State College basketball coach Roger Craft witnessed him kicking a football after a workout one day. Stenerud quickly found himself on the Bobcat football team, where he smashed distance records and nailed field goals. An impressive 59-yard field goal in 1965 set a new NCAA record, and he was included on the All-America team as a senior. He went on to play professionally for the Kansas City Chiefs, Green Bay Packers, and Minnesota Vikings. (Courtesy of Montana State University Athletic Department.)

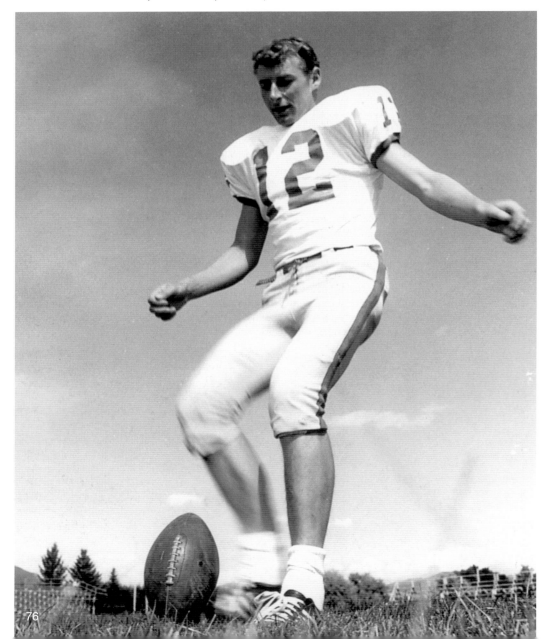

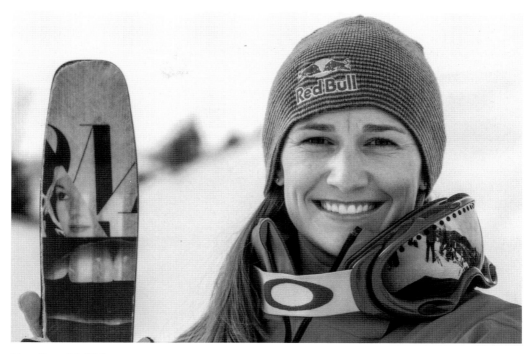

Heather McPhie

Olympic mogul skier Heather McPhie comes by her love of snow honestly. Her great-grandfather, Sam Eagle, delivered mail on skis around West Yellowstone in the early 1900s. Heather competed as a gymnast in her youth, but the call of the mountains prevailed, and she used her tumbling experience to master elaborate aerial tricks in moguls skiing. Her hard work paid off in 2007, when she won World Cup Rookie of the Year, but her career exploded when she won second place at the 2010 World Cup. In addition to competing in two Olympics (Vancouver in 2010 and Sochi in 2014), McPhie pushed her sport's boundaries when she became the first woman to successfully perform two famously difficult tricks in one run during competition. Besides her passion for boosting self-confidence in girls, McPhie loves the adrenaline rush she gets when flying through the air on her skis. (Both, courtesy of Heather McPhie.)

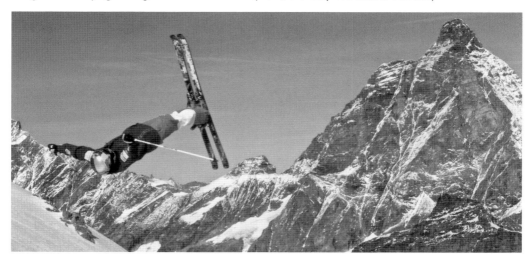

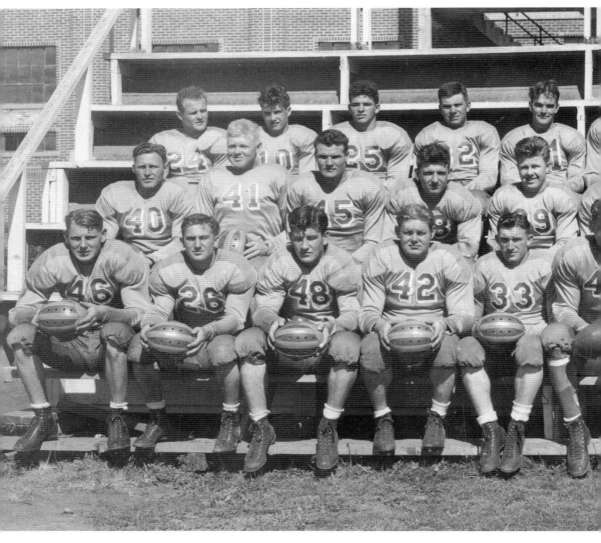

Montana State College Football Teams, 1939–1941
The Montana State College football teams of 1939–1940 and 1940–1941 lost more players in World War II than most sports teams in history (the 1940–1941 team is pictured here). According to a 2011 article in the *Bozeman Daily Chronicle* by Jodi Hausen, titled "A War on Two Battlefields," it is possible that

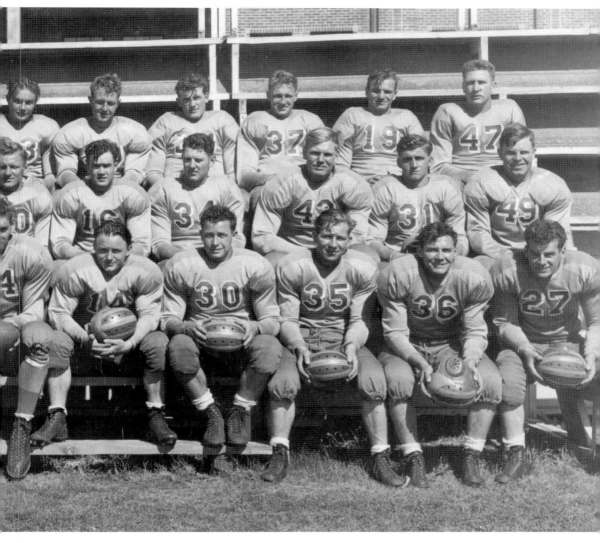

every starter died in the war (informal roster records make this determination difficult). A plaque at MSU memorializes 13 fallen Bobcat football players, including standout Albert Zupan (not pictured), who died in a plane crash in Texas in 1943. A B-17 bomber was later named the "Jon C and Ad" in honor of Zupan's son, Jon Charles, and wife, Adelae. (Courtesy of Montana State University Special Collections.)

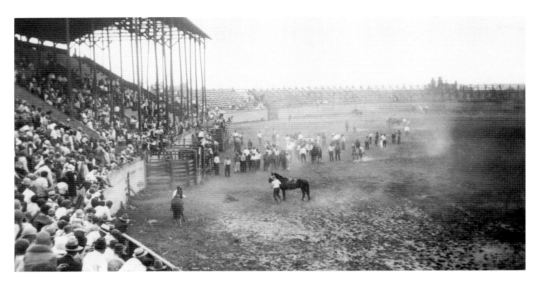

Bozeman Roundup

In 1919, local investors made plans for a new signature event—the Bozeman Roundup. Optimistic that the Roundup would rival the big northwest rodeos in Oregon and Wyoming, organizers built an enormous 15,000-seat grandstand and arena that occupied four square blocks south of today's Gallatin County Fairgrounds. Held each summer through 1926, the Bozeman Roundup awarded cash prizes and attracted thousands of tourists with the slogan "She's Wild!" Famous cowgirls, like the five pictured below, competed in traditional male events like steer wrestling and bronc riding and performed daring stunts like the two-horse Roman Jump over an automobile. According to a paper by Phyllis Smith, "The Outrageous Cowgirls: A Golden Era in Rodeo," accidents frequently occurred, and famous Idaho-born bronc rider Bonnie McCarroll (in center) died in 1929 after her mount at the Pendleton rodeo fell backward on top of her.

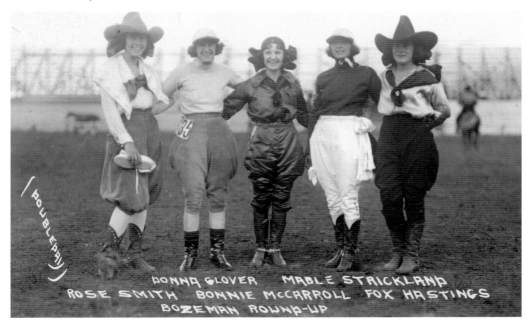

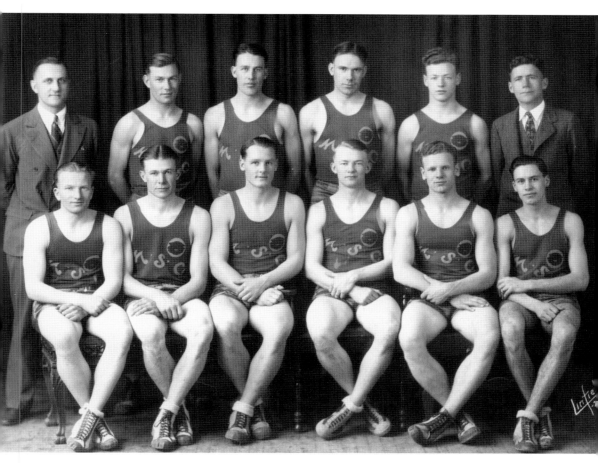

Golden Bobcats

The Montana State College "Golden Bobcat" basketball team of 1928–1929 could be considered the most impressive basketball team in Bozeman history. In 1927, George Ott Romney coached the team to an impressive 26 wins, losing only twice. The next season was even more incredible under coach Schubert Dyche, with a 36 to 1 record. Notable players included Orland and Frank Ward, John "Brick" Breeden, and Max Worthington, but rising star John Ashworth "Cat" Thompson (fourth from left in the front row) stood out. The extremely quick Thompson played the forward position, where he snuck around opposing players and scored an average of 17 points per game. Thompson, an All-American, ended his basketball career with an impressive 1,539 points and was inducted into the Basketball Hall of Fame in 1962.

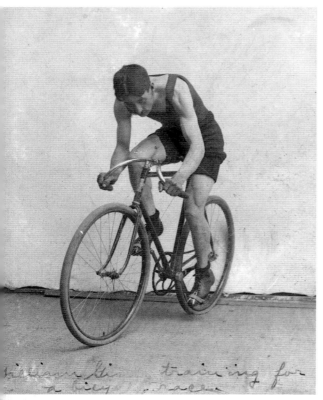

william lli...... training for a bicy...... racu.......

William Ginn

Sportsman, business owner, and competitive cyclist William Ginn operated one of Bozeman's first bicycle shops. Ginn moved to town at the start of the 20th century, when cyclists were forced to choose between riding on uneven wooden sidewalks or rut-filled dusty streets, which, after a good rain, mired their bicycles in sticky mud. A fierce competitor, Ginn beat the local favorite in a grueling five-mile road race in July 1901, cementing his reputation as a talented competitor. To support his young family, the Iowa native turned his cycling passion and knack for mechanics into a career. William and his father, James, opened a bike repair shop on Main Street, which later diversified to include automobile repair. Ginn's enthusiasm for hunting and fishing matched his fondness for cycling, so for a time, the family-run shop also offered skilled taxidermy work. Ginn passed away in 1946.

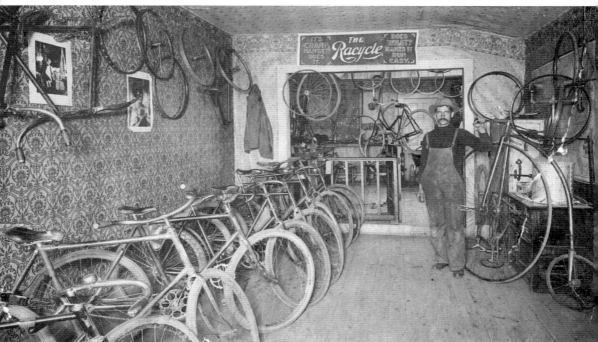

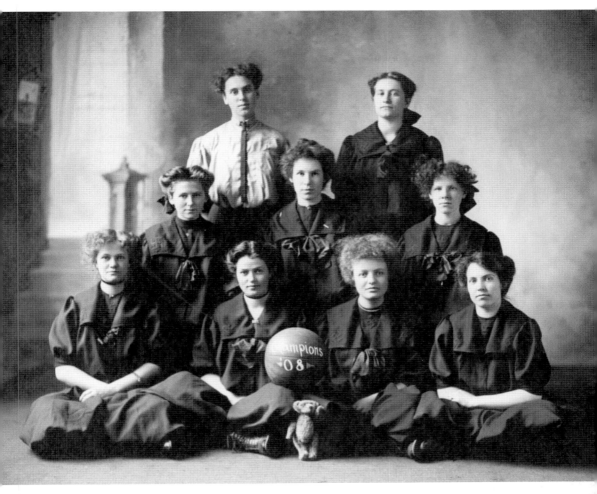

Gallatin County High School Girls Basketball team of 1908
In 1908, the Gallatin County High School girls' basketball team won the state championship despite wearing heavy bloomers and cumbersome blouses. The team's coach, Anna Krueger Fridley, was a Bozeman native who graduated from Montana State College. After coaching, Anna and her husband, Charles, homesteaded near Reed Point, Montana. Tragically, Charles died after contracting pneumonia during the Spanish Flu epidemic in 1918, leaving Anna to care for the couple's six-year-old son, Charles Edwin Jr. Anna lived to age 93. After the team's victory in 1908, organized girls' basketball competitions ceased, and it was 70 years before Montana high school girls again competed for a state championship in basketball.

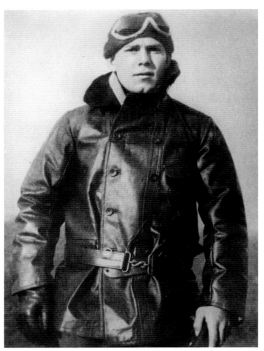

Cyrus Gatton

During his four years at Gallatin County High School, multi-sport star Cyrus Gatton competed in football, basketball, and track. He played fullback on the Bobcat football team, where he impressed peers and instructors with his athletic talent as well as his positive, sportsman-like attitude. With the outbreak of World War I, Gatton entered pilot training in France. He flew bombing missions over Europe and received awards and commendations for his bravery and air combat skills. Just days before the war ended in November 1918, Gatton's plane was shot down in France during a skirmish with a German squadron. Gatton was reported missing in action, but his grave was eventually located in 1919. In a formal ceremony on October 5, 1930, the athletic field at Montana State College was christened Gatton Field in his honor. Gatton's mother, Marietta, and sisters Laura (left) and Harriet (right) are pictured below next to his memorial plaque around 1930.

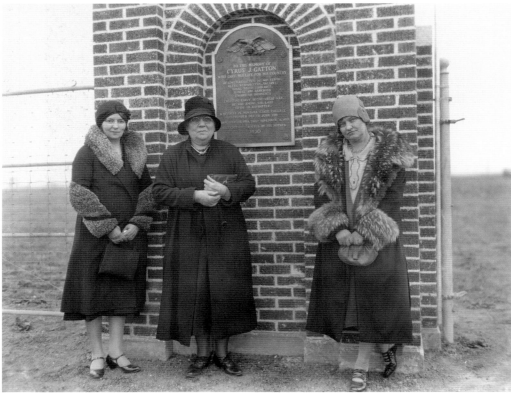

Sonny Holland

Legendary Bobcat football player and coach Sonny Holland grew up in Butte. During high school, the all-around athlete competed in basketball, football, and track. According to Holland, he is sure that if his school had offered wrestling, he would have done that, too. In 1956, football took precedence when Holland joined the Bobcats as a center and middle linebacker. Montana State College football won their first ever national championship that year, so, in Holland's words, he arrived "at a good time." Holland began coaching immediately after college, working in Great Falls, Dillon, and Washington state before returning to Bozeman. He spent seven years as head coach of the Montana State football team, reliving the thrill of winning a national championship again in 1976, this time as a coach. Now retired, Holland spends his time fishing and cheering on his beloved Bobcat football team. (Courtesy of the Montana State University Athletic Department.)

Alex Lowe

Alex Lowe was fearless. Growing up in Missoula, where his father taught in the University of Montana's forestry school, the tall, wiry, endurance athlete reveled in the outdoors and the physical challenges it provided. As a child, Lowe backpacked, hiked, and hunted with his family, channeling the rest of his pent-up energy into obtaining the Boy Scouts' prestigious Eagle Scout rank.

Lowe received a scholarship to study chemical engineering at Montana State University and moved to Bozeman, where he discovered the thrill of rock and ice climbing in the nearby mountains. His newfound passion for climbing contributed to a temporary change in plans, and Lowe postponed school to fulfill his need for adventure. Working in Wyoming on a seismograph crew provided just what he was looking for—a flexible schedule and funds to support traveling. After marriage and a return to Bozeman, Lowe finished his bachelor's degree in applied mathematics and started graduate school.

By this time, Lowe was an experienced world-class climber, and he began leading expeditions to some of the world's highest peaks. In 1990, he became the 40th American to reach the top of Mount Everest, and he summited a second time in 1993. Lowe's expeditions took him everywhere: Yosemite National Park, Canada, the Himalayas, and South America. When not out climbing, Alex regularly went on 20-plus-mile runs in the mountains around Bozeman, asking his wife, Jennifer, to drop him off on one side of a mountain range and pick him up several hours later on the other side. He also pioneered new ice climbing routes in the now-popular Hyalite Canyon area south of Bozeman. Never idle, Lowe enjoyed reading, playing the violin, and juggling when not exercising his body.

In 1999, Alex Lowe passed away in an avalanche on Mount Shishapangma in Tibet. Thousands attended his public memorial service at Montana State University, a testament to Alex's magnetic personality and his genuine interest in the people around him. In 2005, a 10,000-foot peak in the Gallatin National Forest was named Alex Lowe Peak in his honor. (Courtesy of Jennifer Lowe-Anker.)

CHAPTER FIVE

Artists and Entertainers

Even before Bozeman had the size, infrastructure, and population to support theaters or cultural centers, music was a valued art form. William Alderson admitted in his 1864 diary that he sang in the shower, but Emma Willson's arrival must have greatly advanced Bozeman's cultural status. According to local lore, Willson stopped fights in the street outside her open window when her angelic voice wafted through the air.

The Ladies Imperial Band was organized in 1906, giving local women a unique musical outlet. Though short-lived, the band featured a large variety of instruments, quality music, and spectacular costumes. Usually seen marching down Main Street in the Sweet Pea Carnival Parade, the Ladies Imperial Band also played for the annual Elks Convention and Fourth of July celebration. In the same musical tradition, after studying under world-famous musician Christopher Parkening in the 1980s, classical guitarist Stuart Weber has since made his own mark on music history. A prolific writer, Weber has released seven albums, including a collection of recordings made in historic theaters.

Bozeman's love of the arts includes a reverence for its classic buildings. An examination of eclectic Bozeman architecture is not complete without mentioning designer Fred Willson, who can only be described as a structural artistic genius. The son of early Bozeman pioneers, Willson's talents pepper the local landscape in the form of schools, hotels, theaters, commercial buildings, and private homes. Proficient in numerous architectural styles, Willson is, in essence, Bozeman's architect.

Visual artists like Susan Blackwood and Howard Friedland have found international recognition for their paintings and love teaching art at home and abroad. By bringing nationally known artists to Bozeman, they provide local painters with amazing opportunities. Dozens of indoor and outdoor sculptures emanated from Jim Dolan's creative mind. The welded nail figures of his college days have morphed into larger-than-life metal horses with moving joints and flowing tails. Creating with film rather than on canvas or metal, Albert and Alfred Schlechten documented Bozeman history during the first half of the 20th century via their camera lenses, with their output ranging from family portraits to spectacular mountain views.

There is no shortage of imagination in Bozeman. Science fiction novelist Kathy Tyers Gillin successfully transports readers to incredible new worlds while weaving exciting plots and fascinating characters into her popular books. Bozeman-based illusionist Jay Owenhouse began performing at age 14 and now takes his live show on tour all over the world, but always includes a stop in his home town. Film actor Gary Cooper got his start in show business while finishing high school in Bozeman, where he rather reluctantly performed in the senior class play. Cooper appeared in nearly 90 movies before his death in 1961 and is still considered one of the greatest actors in the history of American film.

Sweet Pea Queen Kathryn Hanley and the Sweet Pea Carnival

In August 1906, the first Sweet Pea Queen, Kathryn Hanley (shown here at right with her court), was crowned in an evening ceremony in downtown Bozeman. The *Avant Courier* newspaper reported that the event included a speech by Sen, Thomas Carter, who complimented the idea of the Sweet Pea Carnival, saying, "morbid tendencies will be dispelled and healthy thought will obtain . . . bad people do not love poetry and sweet peas."

The Sweet Pea Carnival began as a tourist event. The local Commercial Club longed for a signature Bozeman celebration that would attract out-of-town visitors—and their wallets. August seemed a good month, when it was dry and the fragrant sweet pea flowers were at their finest. Bozeman residents worked all year to prepare for the celebration, making hundreds of decorative paper blossoms with which to festoon carriages and floats. During the parade, spectators admired decorated storefronts while bands and floats passed down the column-lined street and underneath a temporary welcome arch.

Though the annual event was a success, 1916 marked the final year of the Sweet Pea Carnival. World War I halted celebrations, and the carnival soon became a distant memory. In 1978, a small group of local citizens revived the event under a new name, the Sweet Pea Festival of the Arts (pictured here at lower left in the 1990s). Today, the Sweet Pea Festival is bigger than ever, emphasizing art, theater, and music. Though the celebration has evolved over time, a parade and a sweet pea flower theme still pay homage to the original carnival.

What happened to the first Sweet Pea Queen, Kathryn Hanley? Following her reign, "Katie" married a local boy, Ralph McComb. Sadly, their marriage was short-lived, and Katie and Ralph died four months apart during the influenza epidemic in 1918–1919, leaving behind two small boys.

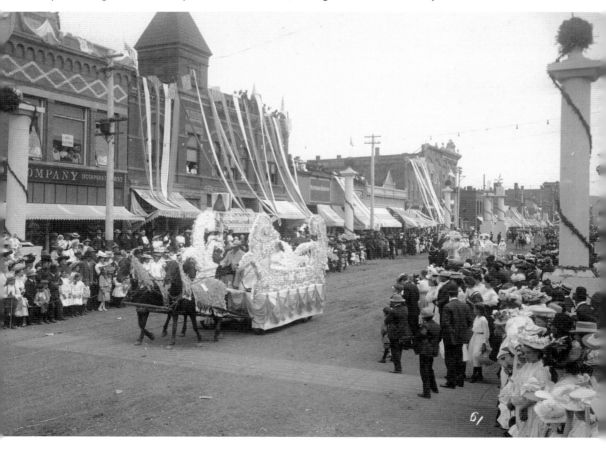

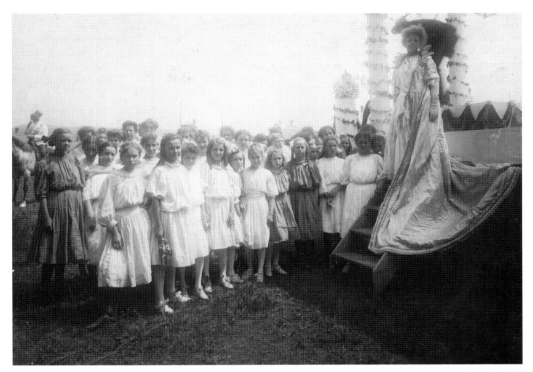

Jay Owenhouse

From an early age, Jay Owenhouse knew he wanted to be a magician. His childhood in Northern California was spent watching magic shows, learning tricks, and developing exceptional sleight of hand skills. He performed his first show at age 14, and soon after, he met his friend and mentor, magician Doug Henning. Family ties to the Gallatin Valley brought Jay to Montana State University, where he met his wife, Susan, and earned a degree in psychology in 1990. Based out of Bozeman, the Owenhouse family developed an innovative and internationally renowned touring show, complete with mind-bending illusions and trained tigers. Besides serving as an advocate for the world's endangered tiger population, Jay's resume includes designing illusions for other world-class magicians and performing in China and Japan. Every year, Owenhouse and his crew work their magic in Bozeman to a wide-eyed and amazed home crowd. (Both, courtesy of Jay Owenhouse.)

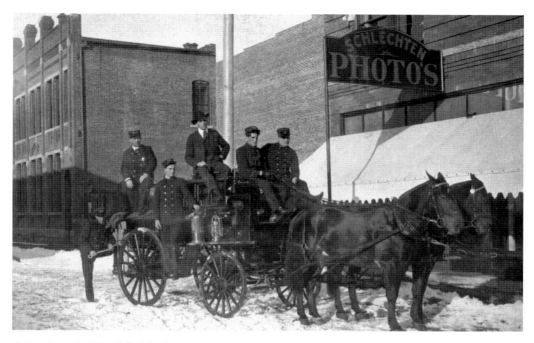

Albert and Alfred Schlechten

In Bozeman, the name Schlechten is synonymous with photography, whether it be portraits, landscapes, or anything in between. Brothers Albert and Alfred Schlechten were born in Switzerland but settled in Bozeman in 1900, soon opening their own photography studio. Conveniently, Albert (or "Big Slec") enjoyed taking landscape photographs, while Alfred (or "Little Slec") excelled in studio work. Between the two, Bozeman's citizenry and countryside were both well photographed. The Schlechten photograph below depicts saddle horses taking a break during a ride in the Spanish Peaks.

Ellen Theater

On December 1, 1919, an ornate, state-of-the-art theater opened on Main Street, capable of accommodating both live entertainment and motion pictures. Designed by local architect Fred Willson, the Ellen Theater featured an elegant design, upstairs banquet hall, and, later, a $25,000 theatrical organ to accompany silent films. Major financial backing for construction came from Nelson Jr. and Thomas Byron Story, who christened the theater "Ellen" in honor of their mother, Ellen Trent Story, wife of Bozeman businessman and cattle rancher Nelson Story. The Ellen thrived for decades but suffered a decline in the 1990s. Fortunately, Montana TheaterWorks purchased the theater in 2005, and after extensive renovations the Ellen Theatre reopened in 2008 as a successful performing arts venue.

Kathy Tyers Gillin

At an author's party in San Francisco, Bozeman author Kathy Tyers Gillin remembers riding on a bus loaded with other Bantam Books science fiction writers as they headed for a tour of George Lucas's Skywalker Ranch. A childlike awe descended on the bunch as they passed into the compound, and someone began to play the Star Wars theme song on a harmonica. Gillin is among an elite group of Star Wars novelists, but her success does not end there. The author of eight science fiction novels (including the popular *Firebird* series), she is a self-described bookworm. She studied chemistry and microbiology at Montana State University in the 1970s, giving her a solid background for weaving science fiction and fantasy tales. Also a talented flutist, she has played with the Bozeman Symphony, the Intermountain Opera, and her church worship team. (Courtesy of Kathy Tyers Gillin.)

Jim Dolan

Jim Dolan's interest in metal sculpture began in his college welding lab, where he created small cowboy and horse figures from welded nails. After earning two agriculture degrees, benefitting from a really great welding instructor, and taking no art classes whatsoever, Jim went to work as a school bus driver in Bozeman; that was the last W-2 he ever completed. A versatile metalworking magician, Dolan excels in fashioning life-sized (and larger) animals with moving joints. Some of his favorite sculptures are his historical figures—Abraham Lincoln, Jeannette Rankin, and Walt Whitman (pictured here on the Montana State University campus). In 2013, as a gift to the people of Montana, Jim completed a herd of 39 metal horses. They calmly graze on a hillside west of Bozeman, their manes and tails dancing in the breeze while the Tobacco Root Mountains shine in the distance. (Photographs by Emily Marks.)

Fred Willson

The son of Gen. Lester and Emma Weeks Willson, architect Fred Willson graduated from Columbia University in 1902 and studied in New York and Europe before returning to Bozeman to establish his own firm. Incredibly prolific, Willson designed nearly 1,800 structures during his career, which spanned five decades. Unlike most architects, he did not have one defining style, and he mastered Art Deco just as easily as Mission Revival. His diverse structural legacy stretches across Montana and serves as a lasting monument to his creative genius. The Baxter Hotel, Willson School (named in Fred's honor), Gallatin County Courthouse (pictured at right), First Presbyterian Church, Ellen Theater, Soldier's Chapel in Big Sky, West Yellowstone's Eagle Store, and dozens of private homes represent just a few of his lasting accomplishments. (Right, photograph by Emily Marks.)

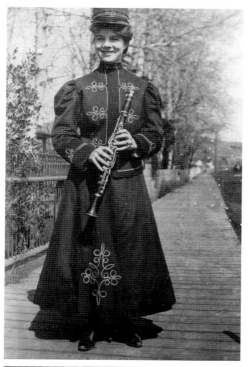

Anna Huffman and the Ladies Imperial Band

Anna Huffman was born in Bozeman in 1889 and, according to her marriage announcement in 1914, was considered a "talented musician." Huffman played clarinet in the Ladies Imperial Band, an organization established in 1906 under bandleader J.C. "Jesse" Thompson. In an era with limited opportunities for women to showcase their talents, the band provided a creative outlet for Bozeman's musically inclined wives, sisters, and daughters. The group was known for their one-of-a-kind costumes, which ranged from long white dresses to tuxedoes. The Ladies Imperial Band performed at a variety of events, including Sweet Pea Carnivals, Elks conventions, and Fourth of July festivities. After her marriage to George Orswell in 1914, Anna Huffman moved to Eugene, Oregon, and happily resided there with her husband until her death in 1939.

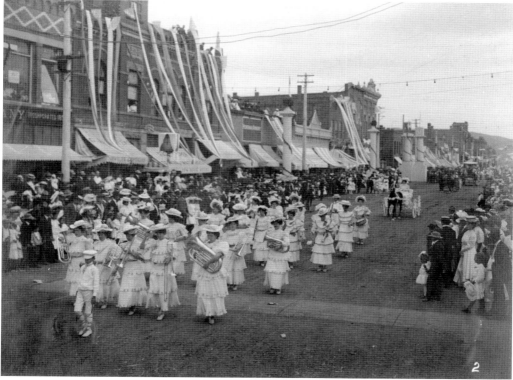

2

Ed Pegram
Popular local musician Edwin "Peg" Pegram learned to play theater organ while living in Dillon, Montana. The son of musicians, "Peg" was attracted to the organ early in life, eventually becoming one of only a handful of people proficient in playing a theater organ. Much rarer than church organs, theater versions could create diverse sound effects, leading to their use in accompanying silent films. Bozeman's Ellen Theater acquired such an instrument in 1924, and after Pegram's arrival as theater manager in 1929, he became an expert. In the mid-1960s, Pegram recorded an album titled *On the Wings of Love*, showcasing the Ellen's theatrical organ. Edwin Pegram passed away in 1984 after countless concerts and decades spent in the theater business.

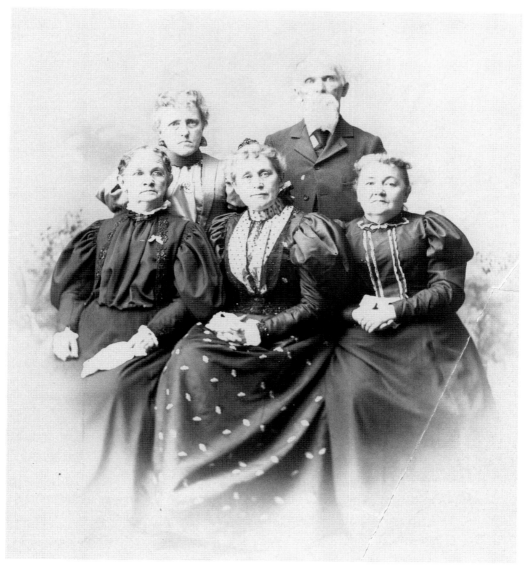

Emma Weeks Willson

Emma Weeks Willson (pictured in center) came to Bozeman in 1869 without her piano, which arrived a short while later from New York. Likely the first such instrument in Bozeman, it attracted almost the same degree of attention as a new female resident. While growing up on the East Coast, Willson studied music in Albany, New York, where she met her husband Lester at a home for disabled Civil War veterans. Later, Emma serenaded passersby from the open window of the Willson's first home on Bozeman's Main Street, and according to her 1923 obituary in the *Bozeman Daily Chronicle*, her music was "instrumental in stopping serious disturbances on the streets of the city." A devoted member of the First Presbyterian Church, Emma played and sang for church functions, including each new pastor's installation. When the new opera house was constructed in 1890, Willson tested the acoustic quality, offering her much-respected opinion.

Susan Blackwood

Born into a family of artists, Susan Blackwood can trace her genealogy back to Rembrandt's parents. A lifelong artist, Blackwood drew under tables and in closets as a child. After obtaining degrees in fine art and environmental design from Northern Illinois University, she worked as an interior designer and taught art at an American school in Pakistan. Despite having no training as an art instructor, the experience hooked her, and she fell in love with teaching the art of painting. Susan married fellow artist Howard Friedland in 1998, and the pair currently host workshops at their Bozeman-area studio, in addition to teaching internationally. An expert in watercolors and oils, Blackwood's favorite subjects are people and animals. The award-winning artist considers her greatest honor, "other than marrying Howard," to be her Best of Show award from American Women Artists for the piece shown below and titled "So What'll You Have?" (Both, courtesy of Susan Blackwood.)

Howard Friedland

A New Yorker by birth, Howard Friedland graduated from art school before launching a career in advertising. In the early 1970s, he returned to painting, and, as he describes it, art began to quickly "get in my blood." Friedland pursued painting in New Mexico before his move to Bozeman in 1998, where he spent his first two years at a studio in the Emerson Cultural Center. Though Friedland specializes in oil landscapes, cityscapes, and animals, he notes that he and his wife, Susan Blackwood, still "pretty much paint everything." In 2008, Friedland won the grand prize Best of Show award at the Oil Painters of America National Exhibition, for one of his favorite paintings, "Morning in Giverny" (seen above). Still impressed with Bozeman's art-friendly community and inspirational landscapes, Friedland frequently takes time to enjoy *plein air* painting in the mountains. (Both, courtesy of Howard Friedland.)

Gary Cooper

Connoisseurs of classic American film may recognize the young man pictured above (at right) with the mischievous look. Though not a true Bozeman native, Gary Cooper did graduate from Gallatin County High School. Frank Cooper (the name "Gary" was adopted later in his film career) was born in Helena, Montana, in 1901. His father, Charles H. Cooper, emigrated from England at age 19 and worked his way up to a position on the Montana Supreme Court. When Frank was five years old, his father purchased a ranch on the Missouri River 50 miles north of Helena. The future movie star grew up in the country, riding horses and creating plenty of mischief.

What Helena residents referred to as the Great Limburger Cheese Caper of 1920 got Frank transferred to Bozeman to finish his education. According to legend, Frank and his buddy spread Limburger cheese all over the Helena High School radiators one night. A not-so-pleasant aroma wafted from the heaters the next morning, causing an evacuation of the school and quite a bit of trouble for Frank. Judge Charles Cooper promptly transferred his unruly son to Bozeman to finish high school in a new venue.

At Gallatin County High, teacher Ida Davis left a lasting impression on Frank Cooper (the tall fellow with the cap in the middle of the group at upper left). Davis persuaded her reluctant student to participate in the senior class play—his first acting experience. Years later, now-famous actor Gary Cooper often stopped in Bozeman to visit his former teacher on trips back to Montana. In 1961, *Look Magazine* documented one of Cooper's trips home and published a touching photograph of Cooper taking Ida Davis out to lunch.

Cooper stood out in high school, probably due more to his height than his acting talents. An avid cartoonist in his younger years, Cooper decorated the scrapbook page at left for one of his high school classmates. His motto in the 1922 Gallatin County High School yearbook reads, "Smoking never stunted my growth." Cooper went on to appear in almost 90 movies throughout his career, including favorites like *The Virginian* (1929), *Sergeant York* (1941), and *High Noon* (1952). He died of cancer in 1961.

Stuart Weber

Born and raised in Great Falls, guitarist Stuart Weber grew up longing to be a cartoonist. He started playing the guitar at age 10, admiring the Beatles, Neil Young, and the acoustic sounds of the 1970s. In the 1980s, Weber studied music at Montana State University under world-famous classical guitarist Christopher Parkening, and he was swiftly pulled away from cartooning by the guitar's absorbing complexity. Throughout his long career, Weber has graced stages throughout the United States, Mexico, and Italy, but his greatest interest lies in writing original music inspired by mountains, weather, and old Montana back roads. Among Weber's seven albums, his favorite project remains a collection of recordings made in historic theaters and opera houses across the western United States. Still "nuts" about the guitar, Weber enjoys playing concerts at local nursing homes and using the instrument as his artistic "medium to document his surroundings." (Photograph by Audrey Hall; courtesy of Stuart Weber.)

CHAPTER SIX

Inspirational Figures, Characters, and Others

Some people, through exceptional qualities or unique character, are able to transform a town into a community. In the 1970s, when Bozeman outgrew the old Carnegie Library, Mary Vant Hull and a friend brought attention to the issue by writing "we need a new library" on their water bills every month. Vant Hull did not stop with libraries, channeling her contagious energy (along with an army of volunteers) into enhancing parks and recreation areas in Bozeman.

Mary Long Alderson pushed for women's rights in Montana. She led the charge in women's suffrage and advocated an end to women's constrictive clothing, like corsets and dragging skirts. Similarly, physician Dr. Caroline McGill's impressive antique collection and love of Montana history led to the creation of the McGill Museum at Montana State University. Dr. McGill's dream has grown into a world-class institution, now known as the Museum of the Rockies.

Through the years, community characters have continued to color Bozeman life. Charles Marble, also known as "Buckskin Charley," guided hunters and owned a successful taxidermy business. When exhibiting his work at the 1893 Chicago World's Fair, he put on his old buckskin attire and grew his hair long to resemble the image of a "mountain man."

In 1933, Montana State College officials received a shock when the newly-printed college yearbook looked radically different than the previously approved draft. An unkempt fictional student named Clarence Mjork had mysteriously inserted himself into nearly every page of the annual, posing with sorority members, clubs, and academic groups. Mjork was the brainchild of photographer Chris Schlechten and yearbook editor Dave Rivenes, who got into a bit of trouble for their antics but created an award-winning collector's item.

Inspiring individuals like streetcar driver Larry O'Brien exhibited true dedication. O'Brien cared for his passengers like family, knowing their schedules and waking them for early morning commutes. He diligently delivered college students safely home after campus parties and waited an extra few minutes for late fares. With similar dedication, Jeremy Brooks works at a busy home improvement store but always has time to chat with customers and point them in the right direction. His uncanny ability to remember names is truly impressive.

Some have the ability to touch the soul. Cody Dieruf lost her battle with cystic fibrosis at age 23 but lived her life to the fullest. A magnificent dancer, loyal friend, and proud college graduate, Dieruf's legacy lives on in the Cody Dieruf Benefit Foundation for Cystic Fibrosis and in the lives of countless people she touched. When Bozeman children's author Ben Mikaelsen met Clyde Cothern for the first time, he did not know how powerful and far-reaching their friendship would become. Cothern was born with cerebral palsy and grew up in an institution. Though separated from his childhood friend when he was transferred to Bozeman, he gained another in Mikaelsen. Mikaelsen adopted Cothern as his grandfather, and the two were inseparable for the rest of Cothern's life. Deeply touched by their relationship, Mikaelsen wrote the novel *Petey* based on Cothern's story.

Mary Vant Hull

Mary Vant Hull remembers when she and her friend Kit Miller sparked interest in building a new Bozeman library. It started with a simple message accompanying their checks for water bill payments: "We need a new library." Others joined the cause, and the Friends of Regional Libraries was formed in 1974 with the purpose of supporting libraries across Gallatin County. The organization raised awareness, and a bond issue to build a new Bozeman library passed with 70 percent of the vote. The new Bozeman Public Library building was constructed a few blocks away from the old Carnegie library on North Bozeman Avenue, and Mary's crew oversaw a chain of volunteers who passed books by hand from the old library to the new.

With the new library completed, voters rewarded Mary with a seat on the City Commission. There, she advocated for parks and trails, including the Gallagator Trail that runs through town, as well as the much-loved Burke Park on the ridge above Peets Hill. She initiated formation of Friends of Regional Parks (FOR Parks), helped pass the first $10 million open space bond, and purchased 100 acres from it for a regional park. In 2009, Mary and her crew of volunteers completed one of their most exciting projects, the Dinosaur Playground. Planning took a full year, culminating in a community-wide, five-day building marathon.

Mary Vant Hull is no stranger to hard work and perseverance. She grew up in a small Dutch community in the Midwest and graduated from the University of Wisconsin with passions about a variety of subjects: reading, psychology, journalism, sociology, and English. After living and working in Egypt for seven years, she returned to the United States and settled in Bozeman. She went to graduate school at Montana State University, taught at the local junior high school and college, and served on Bozeman's City Commission for two terms starting in 1982.

A fantastic role model, Mary has profound respect for volunteers. She is an excellent volunteer recruiter and alludes to the fact that people joke when they see her: "Hide, hide, because here comes Mary." Famous for biking around Bozeman (she also jokes that in her former life she was a bicycle), she became addicted to cross-country skiing at age 49—an activity she describes as "heavenly." While she is still involved with community causes, her current goal is to treat those around her with kindness. As she explains it, "now my project is just to be kind to people . . . I just want to help make people be happy." (Courtesy of Mary Vant Hull.)

Cody Dieruf

Cody Dieruf, one of the city's most inspirational people, was born in Bozeman on November 8, 1981. Diagnosed with cystic fibrosis as a child, Cody chose to live a full, active, and meaningful life. She was a terrific dancer and excelled in ballet beginning at age three; she performed as the Snow Queen in the local production of *The Nutcracker* in 1998. After graduating from Bozeman High School in 2000, she attended Lewis and Clark College in Portland, Oregon, studying sociology and anthropology. Cody passed away on April 28, 2005, eleven days before her graduation. She was awarded her bachelor of arts degree posthumously but achieved her dream of graduating from college. Following Cody's death, her family established the Cody Dieruf Benefit Foundation for Cystic Fibrosis, which creates awareness of cystic fibrosis, supports local families living with the effects of the disease, and inspires everyone to reach for their dreams and experience life.

No one can relate Cody's message better than Cody herself. The following was taken from an essay Cody wrote, which her family used as her obituary. "I dream about how I can make the time I have remaining as incredible and meaningful as is possible, and then more. I want to fill my life with as many experiences as my body will allow and to fill each day, each minute, with as much beauty as I can, because I know this body and these minutes are not for forever . . . Facing one's mortality can be a very scary and painful experience, but I also strongly believe that it can be beautiful, too. It is just hard to see sometimes. The sicker I get, the more difficult the little things become, but consequently, the more victories I have—making it up a flight of stairs or down the block or through a slow dance with a close friend, without getting short of breath—triumph! Before long, taking a breath will be the sweetest victory imaginable. But, all so beautiful. Perhaps I, we, should count ourselves fortunate to be able to find the grace, the splendor, the potential in the ordinary, the expected, the taken for granted. *Life.*"

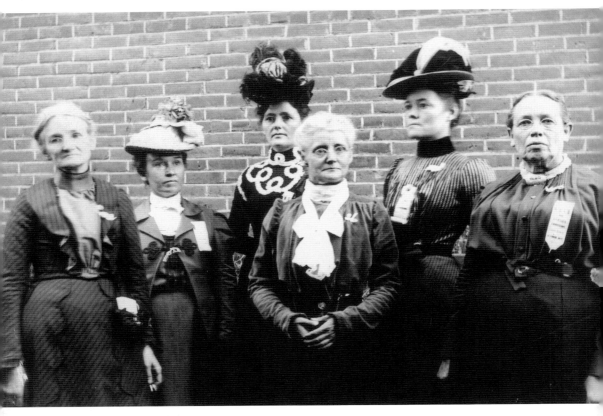

Mary Long Alderson

In an early 20th-century world in which women were restricted by corsets and politics, Mary Long Alderson (shown here, second from left, with fellow officers of the Montana Women's Christian Temperance Union) rose as a shining star. Mary's husband was Matt Alderson, Bozeman newspaperman. She took advantage of her family's media platform to promote her views on temperance, women's suffrage, and sensible female dress, publishing columns in the *Avant Courier* newspaper. In addition to her work as a dedicated member of the WCTU, she also tirelessly campaigned for Montana's adoption of the bitterroot as the state flower and is widely viewed as the driving force behind the flower's ultimate selection. (Courtesy of Montana Historical Society Research Center–Photograph Archives, Helena, MT.)

Larry O'Brien

In July 1892, during Bozeman's campaign to be voted Montana's state capitol, the city inaugurated three brand-new electric streetcars. Trolley routes crisscrossed the town, stretching from the Northern Pacific depot on the city's north side to "Capitol Hill," the high ground now occupied by Montana State University. One motorman in particular impressed passengers. To Larry O'Brien, trolley riders were more than just fares—they were friends. Seemingly all-knowing, O'Brien became a living alarm clock, taking extra time on his trips to stop his streetcar and awaken sleepy patrons whom he knew were planning to board his trolley on the return trip. After college dances and social events, O'Brien and his streetcar would pause patiently, waiting to take students home, while college president James Reid announced, "Young people, Larry is waiting at the foot of the hill."

Charles "Buckskin Charley" Marble
Chicagoan Charles Marble arrived in Montana Territory
as a smart 17-year-old in 1881, just in time to witness
the Northern Pacific Railroad's push west. A frontier-
skills prodigy, Marble became impressively familiar with
southwest Montana and Yellowstone Park. He put his
knowledge to good use and guided wealthy Englishmen
and New Yorkers on hunting trips; they returned
home and recommended his services to their friends.
Marble guided Teddy Roosevelt on a hunting trip along
the Upper Gallatin and Madison Rivers in 1886, then
homesteaded land near the Bozeman Pass and opened
a successful taxidermy business in Bozeman. In 1893,
Marble exhibited some of his finest taxidermy mounts
at the World's Fair in Chicago, growing his hair long and
stepping into the well-known buckskin attire of his youth
in Montana. Charles Marble's personal history, compiled
by historian Francis Niven in 1993, offers researchers
a unique glimpse into the life of a frontiersman. The
book, housed in the Gallatin History Museum, includes
some of Charles's adventures that were dictated to an
interested party in 1932.

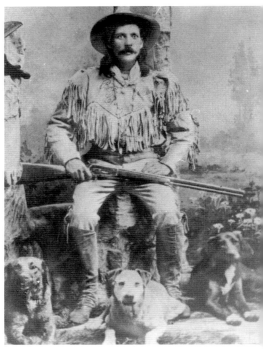

Frank "Doc" Nelson

According to legend and a 1964 *Bozeman Daily Chronicle* article reporting Frank "Doc" Nelson's death, the famed local cowboy received his nickname when he docked racehorse tails as a young man. Whatever the origins of the nickname, it is certain that Nelson was a talented horseman and cowpuncher. In the 1880s and 1890s, "Doc" Nelson worked on cattle ranches across Montana, where he met famed Western artist Charlie Russell. Nelson was likely the inspiration for Russell's famous painting, *Bronc to Breakfast*, when he saddled up a particularly ornery bronc one morning, bucking his way through camp and sending breakfast in all directions. After many adventures as a Montana cowboy (of which Nelson related terrific stories), he worked as a machinist in Bozeman until his retirement in the late 1940s. Nelson was inducted into the Montana Cowboy Hall of Fame and the National Cowboy Hall of Fame.

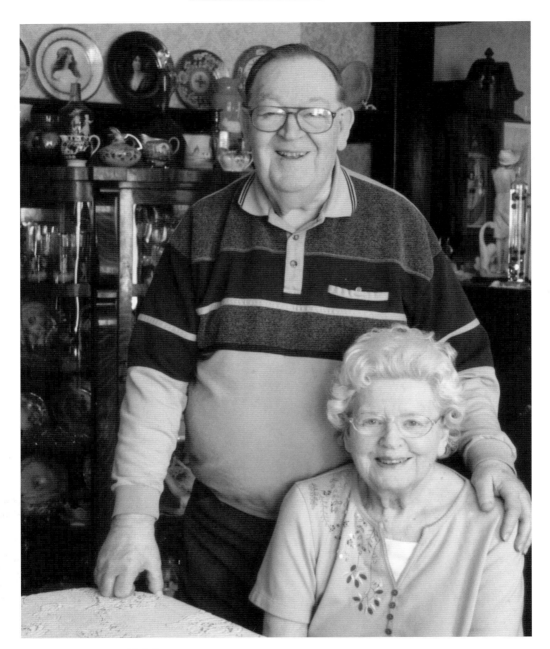

Glenn and Ruth Welch

Glenn and Ruth Welch met at a church group in 1964. A shoe salesman from Chambers-Fisher Department Store with a knack for baking cakes, Glenn grew up in Bozeman's blue-collar north side neighborhood. Ruth Poetter was a pharmacist like her father, E.J. Poetter, who owned a drugstore on Main Street next to Miller's Jewelry for nearly 40 years. After retiring from their respective careers, the couple focused on a shared passion: collecting antiques. Their early-1900s home is filled with incredible antiques of all kinds, from toys to china to pharmaceutical equipment, all of which Glenn laughingly calls their "junque" (spelled with a "q" to lend their collection an air of sophistication). (Photograph by Emily Marks.)

Dr. Caroline McGill

One of Montana's first female physicians, Dr. Caroline McGill, received an impressive education from the University of Missouri, Johns Hopkins, the Mayo Clinic, the University of Chicago, and schools in Berlin. McGill came to Butte, Montana, around 1911 and practiced medicine there for most of her professional life, later retiring to the Bozeman area. McGill purchased the famous 320 Ranch in Gallatin Canyon in 1936 and resided there until her death in 1959. Dr. McGill, a much admired preserver of history, had an impressive collection of antiques that became the core of the McGill Museum (now known as the Museum of the Rockies) at Montana State University.

Susan Huffman

If one went out and about in downtown Bozeman in the mid-1940s, one might stop and take note of the 87-year-old woman piloting the electric cart shown here. According to a feature in the *Bozeman Daily Chronicle* in 1945, the little vehicle provided Huffman with a unique and easy way to make her rounds about town, visit friends, and do a little shopping. Huffman came to Bozeman in 1881 by rail and stagecoach, after which she married local businessman George Huffman. They raised three children together. After George's death in 1903, Susan lived with her oldest son, Hugh, on East Mendenhall Street. This popular cart-driving lady died in 1947 at age 89.

Bobcat mascot

In 1916, more than 20 years after the founding of Montana State College of Agriculture and Mechanic Arts, the school still lacked a popular mascot, and students were growing weary of names like "Farmers" and "Aggies." Lester Cole and Fred Bullock, two editors of the *Exponent* school newspaper, compiled a list of fearsome animals as mascot possibilities. "Bobcat" attracted their attention, and Cole explained the choice in a newspaper editorial: "The ideal name should have a touch of the western, a trace of the Aggie and should be related to the mountains . . . He is not large, but is highly respected by his enemies . . . He does not depend on brute strength alone but upon headwork and cunning . . . Just try to softly warble that name, Bobcats. It can't be done. You have to spit it out." (Photograph by Emily Marks.)

Jeremy Brooks

Veteran Home Depot employee Jeremy Brooks has a mind-blowing talent for remembering names and faces, but that is not the only thing he does well. Devoted to his job and friendly to all, Brooks's dedication to customer service is reflected in the 30-plus service awards he has won. Brooks moved to Bozeman in 2003; he quickly fit right in and made the town his own. Besides loving his job, Brooks enjoys working out at a local gym, skiing, kayaking, and volunteering at the Gallatin Valley Food Bank. He is continually impressed with Bozeman's friendly people and equates the staff at his favorite local restaurant, Santa Fe Reds, with family. "I'm just so happy to know that I have a lot of nice people that look out for me. Everybody in this world should have that." (Photograph by Emily Marks.)

Malcolm Story

Malcolm Story, grandson of pioneer Nelson Story and the inspiration for the pictured statue, grew up loving the outdoors. When Malcolm was a boy, horses, dogs, and hunting dominated his activities. After school in New York, marriage, and a few years in Los Angeles, Malcolm returned to Montana, where he operated the family sheep ranch in Emigrant with his wife and children. In 1958, Story retired to Bozeman, where he kept scrapbooks and recorded information on historic local families, notating books and articles with his trusty red pen. Well into his 80s, Story could be spotted on his daily two-mile walks around Bozeman by his distinctive mustache, Stetson hat, and heavy coat. Malcolm Story passed away in 1994 at age 92, but his statued likeness continues to watch over Main Street from its position in front of the old Gallatin County High School. (Left, photograph by Emily Marks.)

E. Lina Houston and the Bozeman Housekeeper's Club

The Bozeman Housekeeper's Club (pictured here at a club function), formed in 1894, was more than just a club that provided socializing opportunities for local females. By the time it disbanded in the mid-1980s, the 90-year-old organization had the distinction of being one of the oldest women's clubs in the state. Besides fostering an interest in housekeeping and domestic science, early club members also studied books, plays, and art. Members of the club acted as community advocates, pushing for better garbage disposal, assisting the Red Cross, and hosting events for charity. One prominent member in the club's early years was E. Lina Houston, who convinced club members to join the Montana Federation of Women's Clubs. Houston herself was a well-known local woman outside of the club. In 1933, she wrote and published a popular history of the area titled *Early History of Gallatin County, Montana.*

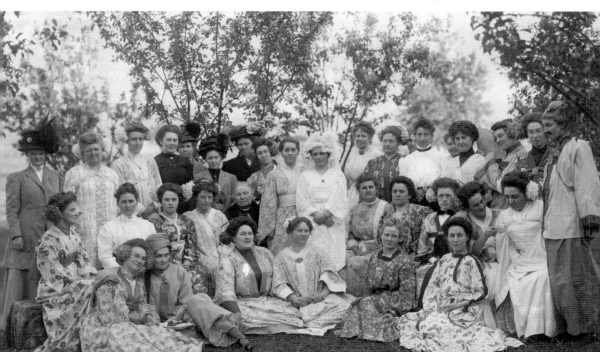

Jennifer Lowe-Anker

Jennifer Lowe-Anker grew up exploring the Montana outdoors, riding horses, and listening to her grandmother's stories. Lowe-Anker studied art in college in Missoula and Bozeman before working in Wyoming in the 1980s, where she met her future husband, climber Alex Lowe. The couple (shown above) later settled in Bozeman, where Jennifer developed a successful painting style using brightly-colored livestock markers. In 1999, after her husband Alex passed away in Tibet, Jennifer established the Alex Lowe Charitable Foundation to provide monetary support and programs to people in remote areas of the world. The foundation supplied emergency aid following the devastating earthquake in Nepal in 2015, and it is currently working to complete a climbing school and community center for Nepalese Sherpas. Jennifer authored a memoir, *Forget Me Not,* and also extends her generosity to local charitable organizations by donating her artwork. (Both, courtesy of Jennifer Lowe-Anker.)

Chris Schlechten and Clarence Mjork

Chris Schlechten (upper left) was born in 1911 to Bozeman photographer Alfred Schlechten. He grew up on both sides of the camera, helping his father in the studio and taking pictures of himself and his friends. For nearly 40 years, Chris took school portraits and class pictures of virtually every kid in Bozeman. Perhaps his most famous (or infamous) project was the 1933 Montana State College annual. Now extremely rare and nationally renowned, this spoof annual featured a fictional character named Clarence Mjork (lower left) on virtually every page. Throughout the volume, Mjork can be spotted posing with clubs and appearing in a variety of scenes.

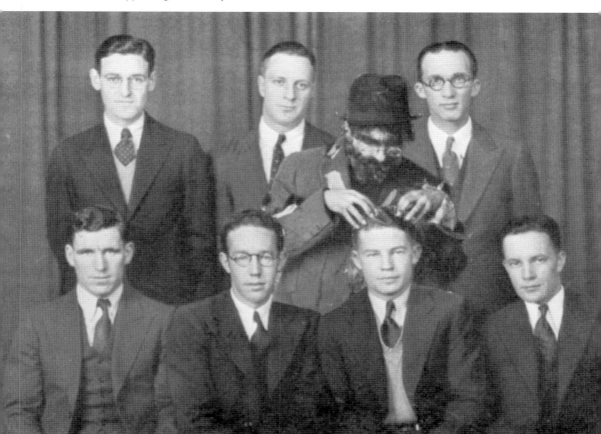

Ray and Kay Campeau

Ray and Kay Campeau took occupancy of their historic South Grand Avenue home in 1967 after admiring it for months. The young Campeau family was surprised when Ray's graduate school art professors, Frances Senska and Jessie Wilbur, each presented them with a $2,500 loan to assist in purchasing the historic Martin family home. Today, the house retains most of the original 1890s furnishings and character. Tablecloths, cut glass, china, and even a clock given away decades before by previous owner Julia Martin have been returned to the house by historically minded recipients. Generous, open, and community-driven, Ray and Kay continue to freely open their home to organizations, groups, and charitable foundations looking for a unique event venue. The Campeaus are active in Bozeman's thriving arts community and enjoy offering their extra living space to artists and musicians. As Kay explains, "The house is kind of our identity." (Above, photograph by Emily Marks.)

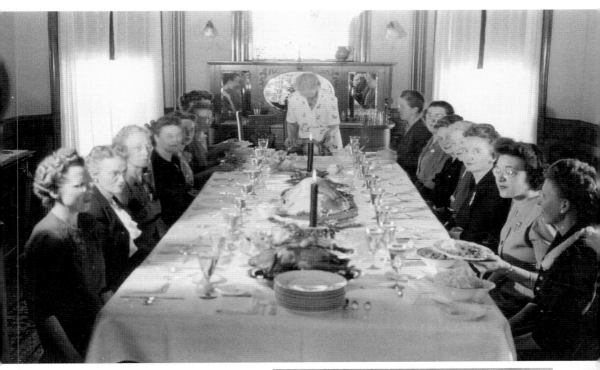

Julia Martin

On Thanksgiving Day in 1945, a group of 15 women gathered in Julia Martin's large dining room. As Julia carved the turkey, the guests (mostly single female educators and academics with no area family) enjoyed each other's company around the long table (above). Julia Martin never married and held a soft spot in her heart for other single women, and she made friends among the students and faculty at Montana State College. The group pictured here includes academics like Bertha Clow, Olga Ross Hannon, and Harriette Cushman. In addition to hosting the annual Thanksgiving dinners, which lasted from 1927 to 1964, Martin opened her spacious family home to college students and faculty, who rented rooms from the basement to the third floor. Julia Martin (pictured at right as a teenager about 1899) passed away in 1966, but her legacy lives on in her South Grand Avenue house, where the current owners, Ray and Kay Campeau, continue her tradition of hospitality.

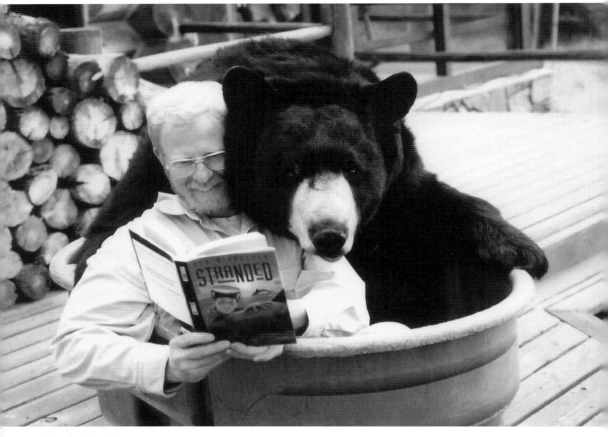

Ben Mikaelsen

Bozeman author Ben Mikaelsen grew up in La Paz, Bolivia, where he attended boarding school. Motivated by a difficult school experience, Mikaelsen found his escape at night, writing under the covers by the glow of a flashlight. During college in the United States, he discovered he was a natural-born storyteller but needed writing practice. A post-graduation motorcycle trip brought Mikaelsen to Bozeman, where the surrounding mountains reminded him of Bolivia. Mikaelsen's writing career began with numerous rejections, but continuous work and involvement in local writing groups led to the publication of his first children's novel in 1991. One of Mikaelsen's most touching books resulted from a deep friendship with Bozeman Care Center resident Clyde Cothern. The two could often be seen on outings around Bozeman, occasionally enjoying the unique company of Ben's rescued black bear, Buffy. The literary result of this incredible friendship was *Petey,* an award-winning fictionalized account of Clyde Cothern's life. Today, Mikaelson uses his platform as a successful writer and engaging speaker to encourage young fans to learn from "Petey moments," those times in life that offer a choice between taking the easy way or the hard way. As Ben explains, the difficult path is "a little hard, it's often awkward . . . but it's the way that has the rewards."

Clyde Cothern
Born with cerebral palsy, Clyde Cothern (inset) spent most of his life in a state institution in Warm Springs, Montana. As a child, Cothern bonded with one of the few other children living at the institution, a boy named Orville McManus. Cothern and McManus survived in an adult ward together, coping with life's difficulties by developing their own language. Sadly, during a reorganization of the institution in the 1970s, Clyde and Orville (then both middle-aged gentlemen) were separated without even a chance to say farewell. Clyde brought his cheerful outlook with him to his new home at Bozeman Care Center, where his popularity led to a new friendship with emerging author Ben Mikaelsen. Mikaelsen was eventually able to reunite Clyde with his old friend Orville McManus, an event that became a highlight for both men. Twelve years before Cothern passed away in 1996, Mikaelsen adopted him as his grandfather in a special ceremony, providing Clyde with the permanent family he had never experienced. Clyde Cothern continues to touch lives worldwide through Ben Mikaelsen's book *Petey*. (All, courtesy of Ben Mikaelsen.)

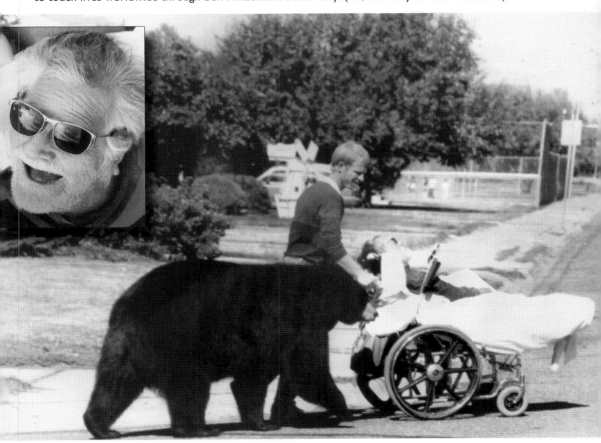

BIBLIOGRAPHY

Alderson, William W. *The Diary of William W. Alderson: Across the Great Plains to Montana in 1864, Settlement in Bozeman and in the Gallatin Valley, Montana. 1864–1877.* Transcribed from originals and with editorial notes by Merrill G. Burlingame, 1976.

Bean, Jack. *Real Hunting Tails.* September 30, 1844–July 1923.

Burlingame, Merrill G. *A History: Montana State University Bozeman, Montana.* Bozeman, MT: Office of Information, 1968.

———. *Law & Order in Gallatin County: Jails, Courthouses, Detention Centers, and Terminal Justice.* 1987.

Cicale, Annie, and Edna Berg, editors. *Cold Smoke: Skiers Remember Montana's Bear Canyon and Bridger Bowl.* Missoula, MT: Mountain Press, 1997.

"Ed Pegram Receives National Recognition." *The Gallatin County Tribune and Belgrade Journal* (December 11, 1969): 16.

Gardner, Flora. "Fort Benton to Bozeman, 1879: A Letter from Flora Gardner to Mr. and Mrs. D.M. Vinsonhaler." *Pioneer Museum Quarterly* (Winter 2009): 7–13.

Garner, Anne. Who's Who in the Bozeman Cemetery: A Guide to Historic Gravesites. Bozeman, MT: The Bozarts Press, 1989.

Peters, Lisa. "Snow Dynamics: The Pioneering Work of Charles Bradley and John Montagne." *Pioneer Museum Quarterly* (Winter 2013): 34–38.

Progressive Men of the State of Montana. Chicago, IL: A.W. Bowen & Co., 1901–1903.

Scott, Kim Allen. *Yellowstone Denied: The Life of Gustavus Cheyney Doane.* Norman, OK: University of Oklahoma Press, 2007.

Smith, Phyllis. *Bozeman and the Gallatin Valley: A History.* Helena, MT: TwoDot, 1996.

———. *Sweet Pea Days: A History.* Bozeman, MT: Gallatin County Historical Society, 1997.

Strahn, B. Derek. "Historic Sunset Hills Walking Tour Tour Guide Script." Bozeman, MT: Gallatin County Historical Society.

Tracy, Sarah J. Bessey. *The Diary and Reminiscences of Mrs. William H. (Sarah J. Bessey) Tracy.* Bozeman, MT: Gallatin County Historical Society, 1985.

INDEX

AN IMPRINT OF ARCADIA PUBLISHING

Find more books like this at
www.legendarylocals.com

Discover more local and regional history books at
www.arcadiapublishing.com